Graphics
Explained

ROCKPORT

BEVERLY MASSACHUSETTS

Graphics
Explained

ROCKPORT PUBLISHERS

7 Top Designers, 7 Briefs, 49 Solutions... In Their Own Words

Michael Evamy

First published in the United States of America by
Rockport Publishers, a member of
Quayside Publishing Group
100 Cummings Center
Suite 406-L
Beverly, Massachusetts 01915-6101
Telephone: (978) 282-9590
Fax: (978) 283-2742
www.rockpub.com

ISBN-13: 978-1-59253-542-2
ISBN-10: 1-59253-542-9

10 9 8 7 6 5 4 3 2 1

Project Editor: Nicola Hodgson
Design: Fineline Studios

Printed in China by SNP Leefung Printers Ltd.

CONTENTS

INTRODUCTION

The subject of this book is designing. Not designing in the sense of the mechanics—grids and font weights and paper stocks—but about how graphic design studios respond to the challenges set before them by clients; how they channel their ideas and inspirations, the methods they employ, the compromises they make, the relationships they forge, and what they learn along the way. It's about all the things that make designing both demanding and exhilarating. So who better to relate these matters than designers themselves?

Outside design conferences and lectures, it's a rare thing to hear graphic design explained in detail by practitioners. Take what you read in the popular press at face value and you might assume that design was devoid of rigor; that corporate identities, websites, books, brochures, magazines, posters, and packaging are designers' doodles one day, and live pieces of communication the next. When a design is seen as public property, such as the visual identity for the London 2012 Olympics, its perceived inadequacies can have column writers rushing to vent their spleen, with deeper considerations of context and value getting lost in the stampede.

Even in the design media, the level of discussion about the design process often struggles to rise above the banal. Designers are only occasionally given the chance to explain their work in any depth, and the opportunities to learn how and why certain designs came into being are limited. At the other end of the scale, there have been academic books and journals that claim to dissect the design process as if it is a fish being prepared for a meal. All too often, the reader is left with just the bare bones, and none of the flesh.

This book seeks a middle course, shedding light on how design takes place in practice, but celebrating the diversity of individual approaches. The stories of how projects unfolded are told, with great candor, by the principals of seven design groups, in their own words. What you hear are seven distinctive voices from around the world, each one representative of a different strand of design, and each one delineating a different set of concerns, interests, and values.

There is the strongly editorial approach of a London group with its own publishing arm. There is the youthful energy and style of a Brussels studio with roots in designing for fashion and music, and a small, young Hong-Kong-based partnership that is making an impression on design juries around the world. Their approaches contrast sharply with that of a distinguished Barcelona-based designer who favors the kind of ideas-based design pioneered by groups such as Pentagram. From New York, there is a studio run by two of the city's most talented designers working across TV, print, and the internet. One group, based in Brisbane, comes from a background of social activism and community-based arts projects, while another, in Singapore, is best known for its interactive work for corporate clients.

The seven chapters each address a particular type of design project with its own dynamics, pressures, and pleasures:

· The New Client
· The Good Cause
· The Wide Open Brief
· Repeat Business
· Low Budget
· New Territory
· The Rush Job

In each chapter, the same seven design groups retrace their steps through a relevant recent project, revealing how they dealt with each project type. They recount the ups and downs of each job, the relationships that they formed, and how decisive moments propelled them toward the delivery of each solution.

How, for example, a book was delivered simultaneously to 500 fashion-show guests with photography inside it of the show the guests had just witnessed. How the inspiration for a signage system came from digits spray-painted onto a packing crate. Or how the members of a band joined a design studio to tear pages out of hundreds of notebooks in an effort to cut costs on the packaging of their latest CD.

Our intention with this book is simply to open the door on design practice: to give onlookers, students, and other practitioners a real, immediate sense of how things happen within design studios, and of the forces that shape design solutions. The book goes some way toward conveying the degree of difference in approach between practitioners—something lacking in most coverage of design—while highlighting the rigor, dedication, experience, and skill that they all feel is essential to the practice of design.

THE DESIGN GROUPS

BROWNS DESIGN
LONDON, UK

Jonathan Ellery co-founded Browns, a multidisciplinary design studio, in 1998 and now runs it creatively with partner Nick Jones.

"Our approach is a straightforward one," says Ellery. "We believe in simplicity, clarity of message, and originality in delivery." Browns' international reputation is built on its ability to bring a powerful, provocative visual sense and a mastery of the print process to publications for clients from global brands such as Invesco, Hiscox, Dries Van Noten, The Climate Group, and Channel 4 Television to small entrepreneurial businesses.

Browns has designed books for, among others, Martin Parr, Lawrence Weiner, Susan Meiselas, Felicé Varini, and photographer John Ross. Browns Editions, the studio's publishing arm, has also created books and catalogs for a number of artists, photographers, and illustrators. Recently, Ellery has focused on publishing his own work, producing four conceptual limited-edition books in as many years.

COAST
BRUSSELS, BELGIUM

Founded by Celia Carerra Schmidt and Fred Vanhorenbeke, Coast is a multidisciplinary brand consultancy. Since 1999, Coast has designed more than 50 identities and branding programs for clients ranging from theaters and cultural organizations to international consumer brands. "We always mix an artistic approach with a pragmatic, strategic translation of brand values," says Vanhorenbeke. The studio's portfolio also includes books, brochures, websites, exhibition design, guerilla advertising, and packaging.

Coast see themselves as a product of their cross-cultural, geographical location, representing a blend of "northern precision and southern passion." With experience at Stylorouge in London, the two partners have kept close ties with the UK design scene, and in 2006 launched a sister studio, Company Coasthomson, in west London.

MARIO ESKENAZI

BARCELONA, SPAIN

Unlike many less gifted designers of his generation elsewhere in Europe, Mario Eskenazi has resisted the lure of expanding his workshop into a bigger business. One of a group of internationally renowned designers who were born in Argentina but practiced in Spain, he established his studio in the late 1970s, and developed a reputation for simple, surprising, ideas-based design solutions. "I have always tried to keep the studio relatively small," says the designer, "to avoid a corporate approach to designing and to maintain a more craft-like relationship with my work."

His small-scale, "personal" approach to business has helped to build a number of long-lasting relationships with clients, most notably the publisher Paidos. Other clients include Banc Sabadell, Retevisión, lighting manufacturer Zumtobel, and furniture companies Andreu World and Perobell.

In 2000, Eskenazi was awarded Spain's National Design Prize. He has been a member of the AGI (Alliance Graphique Internationale) since 1997.

INKAHOOTS

BRISBANE, AUSTRALIA

Inkahoots is a design studio that has been working on the periphery of Australian creative culture since 1990. It entered existence when an inner-city housing crisis in Brisbane prompted a major community poster project that brought together three local artists. Its community-access screenprinting and design studio spent its early years producing bill posters for left-wing causes and community groups.

Today, Inkahoots describes itself as "a primordial multimedia organism," still dedicated to the principles on which it was founded. Robyn McDonald, Jason Grant, Ben Mangan, Joel Booÿ, and Kate Booÿ still create hard-hitting posters, publications, and identities for arts and campaigning groups in Queensland, but also collaborate locally and internationally on projects large and small across a range of media.

KINETIC
SINGAPORE

Kinetic Interactive, part of the Ad Planet Group, was established in 1999 and fast became one of the world's most celebrated interactive design consultancies. "Our creed is simple," says creative director Pann Lim. "We're here to break the barriers that hinder marketing communication, and to explore the creative and conceptual limits of our projects."

Kinetic Design & Advertising was set up in 2001. Originally intended to supplement the studio's web creatives in the print medium, it went on to gain its own independent footing. Armed with the same philosophy that drove the interactive design arm, Kinetic Design & Advertising has gained well-known clients of its own and garnered its fair share of awards. Names on Kinetic's client list include Motorola, Nokia, Honda, Lotus, and Heineken.

MILKXHAKE
HONG KONG

Milkxhake was co-founded by graphic designer Javin Mo and interactive designer Wilson Tang in 2002. Their clients comprise leading creative organizations and businesses in Hong Kong, and their works have been published in numerous magazines.

The studio received three awards of excellence in the Tokyo Type Directors Club 2004–2006 and ten awards in the Hong Kong Designers Association Awards 05. In 2006, following a spell at Fabrica, the Benetton Research and Communication Center in Italy, Javin Mo was named as one of the Young Guns 5 from the New York Art Directors Club.

NUMBER 17
NEW YORK, USA

Number 17, a multidisciplinary design studio, was
founded by Emily Oberman (an alumnus of Tibor Kalman's
M&Co) and Bonnie Siegler (a former design director at
VH1) in the summer of 1993.

The studio's strength lies in the wit and vitality it brings
to a wide variety of its projects in TV, print, and online.
These include the identity and opening sequences for
Saturday Night Live, the development of the new Tina
Brown news website "The Daily Beast," and the design
of the Sex and the City books (for both the series and the
movie). They have also carried out brand identity projects
for companies such as Orbitz and Air America Radio, The
Mercer Hotel in New York, and the overall identity and
packaging for Graco Children's Products.

Oberman and Siegler have both served on national and
local boards of the American Institute of Graphic Arts.
They teach at the Cooper Union, and act as visiting critics
for the Yale University graduate design program.

There is only one place to begin a book about the business of design, and that is with projects carried out for new clients. These are, generally, the most testing and time-consuming for a design studio; a project may be won but there is usually still a client to be won over. Without a healthy, trusting relationship to see it through, the first job for a new client will probably be the last.

Myths and legends abound in the design and advertising industries about strokes of bravado and brilliance that won new clients. The meeting, for example, at which Robert Brownjohn stripped to the waist and danced in front of projected slides to demonstrate to Cubby Broccoli how the *Goldfinger* titles would work. Then there are unforgettable presentations of ideas of the kind captured so brilliantly in the final episode of *Mad Men* (Season 1), at which Don Draper leads the people from Kodak through a moving slideshow tribute to memory, nostalgia, and childhood innocence, to a new name for the client's slide projector: Carousel.

THE NEW CLIENT

Then there is the case of the designer who won the job of designing an annual report and accounts for an international insurance firm, not by joining in with the pitch process but by sending the art-loving chairman a book of his own artistic inspirations. That designer was Jonathan Ellery, the founder of Browns Design, who says on page 15 of his first encounter with Robert Hiscox, "We hit it off and Browns were appointed."

In truth, such gambles, so richly rewarded, are rare. But it's also true that "hitting it off" is an essential step in winning any new client—however you choose to do it.

First, you have to meet the clients. Most of the design groups featured in this book are able to rely on referrals, associations, and word-of-mouth to yield introductions to potential new-clients. Some take steps to help generate that word-of-mouth themselves: Kinetic, in Singapore, make their name visible on every design they create, while Milkxhake, in Hong Kong, put time and effort into winning press coverage to get noticed.

Generally, it is the strength and success of the work by these companies that earns them new business—and a varied supply of new clients. For some organizations, it's the proximity of a design group's client base to their own sphere of business that attracts them. Dockers, for example, liked the look of Coast's previous work for fashion clients. For a few customers, such as the property consortium that hired Number 17 to help market its "sassy little building" in Tribeca, Manhattan, the remoteness of a design group's experience can bring a valuable fresh perspective.

Once the business is in the bag, there is the job of nursing the new relationship. Trust is the key ingredient that determines whether a new client goes on to become a new stream of business. With the projects spotlit here, designers stress the importance of measures such as building personal relationships with clients, establishing common goals and mutual respect, holding regular face-to-face meetings, and, ultimately, creating design that works. Do all that, and sometimes you get invited back.

DESIGN FIRM:

Browns Design

CLIENT:
Hiscox; an international specialist insurance company.

PROJECT:
Annual report and accounts, 2007.

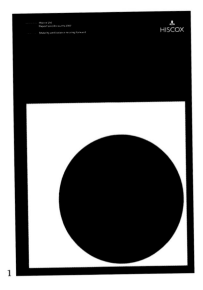

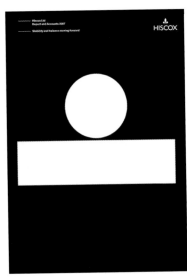

Jonathan Ellery, Founding Partner, Browns Design:
"Hiscox is a highly respected international specialist insurer, with a reputation for integrity and quality. They cover a wide range of personal and commercial risks that other insurers often consider too complex or too much trouble. They have 27 offices in 13 countries, and in 2007 their gross premiums written income was £1.2 billion [US$1.8 billion]. Hiscox are a committed supporter of the visual arts. They boast an enviable corporate collection that includes work by artists such as Damien Hirst, Gavin Turk, Banksy, Jeff Koons, Gilbert and George, and Lucian Freud. The chairman, Robert Hiscox, has said, 'Art is a passion of mine. It is also an integral part of the culture of Hiscox. We insure it, we own it, and we encourage it.'

1–2 Early cover designs, exploring the concept of the annual report as a contemporary art piece.

3–4 Spreads from the final publication, which followed a modernist, graphic approach, printed on pink, black, and white paper.

"Rather than pitching with creative work, we put energy into engaging with the client by presenting case studies of previous annual report work for Hanson plc [suppliers to the construction industry], [British broadcaster] Channel 4, and BAFTA [British Academy of Film and Television Arts]; identity work for Invesco [see pp. 104–107] and The Climate Group [see pp. 44–47]; and examples of integrating culture and commerce, such as bringing art into the public and corporate domains with Howard Smith Paper [see pp. 74–77]. In addition, I sent the chairman of Hiscox a copy of *136 Points of Reference,* a book featuring inspirations and influences on my own artworks, and was invited to meet him on the strength of this. We hit it off and Browns were appointed. Hiscox are renowned for being different. The quality of their expertise and personalized service, coupled with incredible connections to the art world, make them stand out from their competitors. It was clear that Hiscox needed a report that fully reflected Robert's personality and that of the company as a whole.

4

3

"Previous annual reports had aimed to be 'artistic' rather than corporate in their look and feel, but they hadn't quite succeeded. They had interspersed art through fairly dry, corporate reporting in an attempt to lighten it and represent Hiscox's associations with the art world. We wanted to take a different approach and treat the report itself as more of an art piece. By improving the production values, using higher-quality paper and more contemporary design, we aimed to create a covetable report that would stand out from the competition and better reflect the intelligent, 'dare-to-be-different' attitude and culture of Hiscox.

"Robert Hiscox asked Browns to design an annual report that 'told it as it is' in a transparent and open manner. We presented three design concepts. The first route took a contemporary European/London design approach featuring a pictorial exploration of the specialist insurance offered by Hiscox, with specially commissioned photography by Magnum photographer Mark Power. The second was more of a classic New York design approach: an editorial format including articles, Q&As, and case studies. Imagery for this route was to include the use of Magnum photographers such as Harry Gruyaert, Chris Steele-Perkins, and Mark Power. The third route used a modernist, graphic approach on pink, black, and white paper. This route would relieve the pressures and costs that can arise with photoshoots and tight schedules, and could be developed internally by Browns. Robert was initially seduced by the Magnum photography, but he decided the straightforwardness of the third route was ideal.

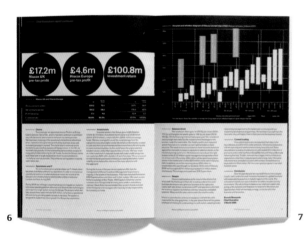

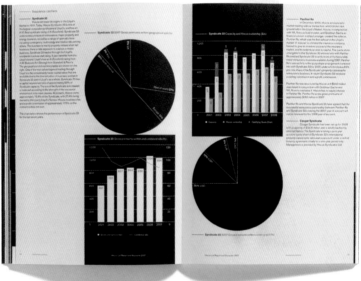

5 Cover of the final publication.

6–7 Spreads from the report, showing the bold, no-nonsense treatment of information graphics.

8–10 Typical spreads, reflecting Hiscox's "dare-to-be-different" positioning in the insurance market.

"As Hiscox were a new client, we held weekly face-to-face meetings with the design manager and communications director to discuss ideas and development, showing printed presentations whenever possible to encourage personal relationships between the teams. Toward the end of the project, when proofs were being turned around daily, we sent PDFs via email, but encouraged constant phone conversations rather than relying on email.

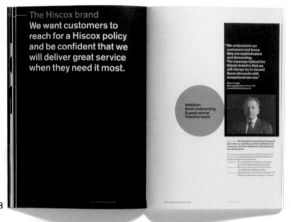

8

9

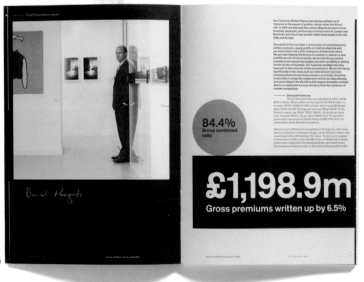

10

"The finished report is part-printed on pink paper, using only two colors—black and red—on FSC [Forest Stewardship Council] paper where possible. It is supported online to minimize its environmental impact. Hiscox were extremely happy with the product. It stands out as a nontraditional report in just the same way that Hiscox stands out from the traditional insurance crowd."

DESIGN FIRM:

Coast

CLIENT:
Dockers San Francisco;
the European division of
the US fashion label, part
of Levi's Group.

PROJECT:
European brand
identity guidelines.

Fred Vanhorenbeke, Partner and Creative Director, Coast:
"We never do anything specific to attract new clients except be kind to
the ones we have and maintain good relationships with contacts and
friends. I believe what helps us a lot is the word-of-mouth
communication about our work; every happy client brings a new one.
The client in this case, Dockers San Francisco, needed to redefine their
identity to regain their market. They weren't happy about using the
American guidelines, although they had to keep the Dockers logotype.
Dockers in the US is positioned in the same category as Gap, but in
Europe Dockers is more of a premium high-street leisure fashion brand.
Also, the guidelines they had were inadequate: there were some rules
about logotype, colors, and fonts, but they were not really structured or
applied in an overall approach.

1

2

1 The Dockers logotype.

2 Screenshots from
Coast's first assignment
for Dockers: a website
using a "holding"
brand identity for the
European brand.

3

"We met the clients in Brussels at Dockers HQ; the first job they asked us to tackle was a new website with a temporary identity. We talked about the brand, and we showed our portfolio. The client had met several design studios before choosing us. We think they picked us because of our background in creating identities for fashion clients such as designer Xavier Delcour and Lee Jeans. They also liked our open discussion process. We always leave space for the clients to express themselves; they are closest to the brand and can give us the key to helping them. The relationship grew step by step. We started on the design of the temporary website, which was a hit. Then we worked on some packaging, which was not a hit. In the meantime, we also worked on the identity proposals. We had to develop a visual language that they could adapt for all their communication needs: stationery, PowerPoint presentations, brochures and leaflets, advertising, billboards, websites, and so on. The visual language needed a layout system, typography and font selection, color selection, and use and photographic direction.

4

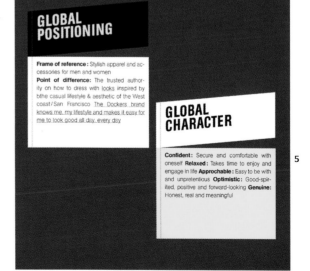

5

3 Early work limited use of the logotype to white in a black rectangle.

4–5 Visuals of Coast's brand definition research.

"To help us research the brand, the client organized a workshop for us to see everything they had produced over the previous five years, which showed us the spread and lack of continuity in their identity. We researched what was missing from the brand; the main quality that came out was authenticity. We had to bring authenticity back to the brand; it's the reason why people buy fashion. At first we struggled to find the essence of the graphic concept. We couldn't focus on one single route, and tried many ways of delivering a consistent approach. The early design ideas focused more on the system than the concept. Route one was based on blocks and colors, but the content was dull: there was no real integration of the San Francisco model, just a gimmick on pictures.

6

7

ABCDEFGHIJKLMNOPQRSTUVWXYZ
abcdefghijklmnopqrstuvwxyz
0123456789$(+%£&)*§...

ABCDEFGHIJKLMNOPQRSTUVWXYZ
abcdefghijklmnopqrstuvwxyz
0123456789$(+%£&)*§...

8

6 An early attempt at finding a visual direction for the European brand ("route one").

7 "Route two" was industrial-looking and incorporated Coast's Akzidenz Dockers font, but failed to reflect part of the Dockers collection.

8 Coast's comprehensive new guidelines demonstrated how the identity should be applied.

9

"Two main things really matter in the creation of identity guidelines: their presentation and their simplicity of use. We proposed that the guidelines should be delivered in high-resolution A4 [8¼ × 11¾ in] PDF files. There was no need to print them, as this would cost more and we didn't have the time. Printed guidelines also become irrelevant when there are changes. We also proposed to divide the guidelines into four sections, allowing people to use them individually.

"We also developed a typographic route (route two) where we created a 'dark' version of Akzidenz-Grotesk (we called it Akzidenz Dockers). The main idea was to return to Dockers' roots: pants for dock workers. This was a kind of industrial typeface, rough and strong. But this route neglected a large part of the collection, which is more subtle and smart, so it was rejected (both by us and by the client). We then went back to their mood boards. One of the most significant inspirations was 1950s and 1960s jazz record covers. This was it: we would mix this graphic language with a modern approach to typography and an authentic photographic language.

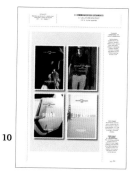

10

9 Classic Blue Note jazz album covers provided the typographic inspiration for the new graphic language.

10 Brand guidelines covered all applications, from signage and stationery to advertising, packaging, and photographic panels.

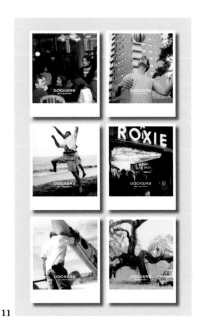 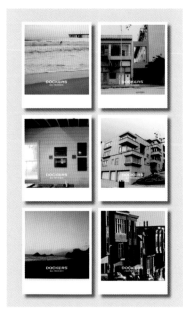

11

"We made drastic choices in order to keep things simple and make a statement. We opted for a centered layout approach. In general, the logotype should be centered. We used the same idea for the typography, which mixed two typefaces—Clarendon and Akzidenz-Grotesk. These two fonts represent the core of the concept. Clarendon is the link with the past and authenticity; Akzidenz-Grotesk is the link with today, and echoes the brand in the US. The combination of the two fonts, like a *cadavre exquis* ('exquisite corpse,' or game of Consequences), shows both in a new light. Both typefaces can be used in titles, with a choice of line spacing. This typographic game, the centered system, and an 'authentic' photographic system (the use of Polaroids, self-made pictures, vintage props, and real people) represent the three cornerstones of the identity.

12

11 Inspiration from San Francisco for new Dockers imagery, with the themes of (l–r) "play," "living in SF," and "authenticity."

12 Cover of the new Dockers "look-book."

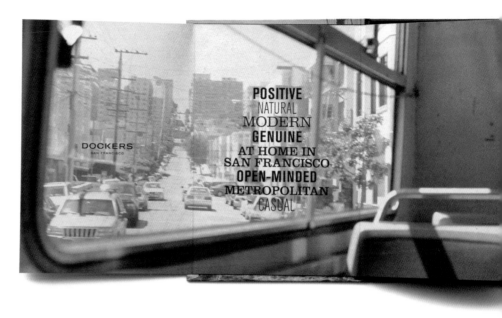

13

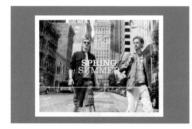

14

"Dockers' European brand team are now using our system. I think it achieved the end of the visual chaos they had had for the previous five years, and delivered a strong foundation that is flexible enough to allow designers to create something new. At the time, these guidelines were the most important and most widely used we had ever done. We learned to be concise and precise. We learned to think global. We learned to think before doing. We had to think of a system that was adaptable to everything, that left no room for misinterpretation. We had to design something people would use widely, from Portugal to Turkey. Different languages would be used, different minds, different attitudes."

13–14 The new Dockers brand book, designed to introduce the new look, and typical pages from the new website.

DESIGN FIRM:
Mario Eskenazi

CLIENT:
Sociedad Estatal para el Desarrollo del Diseño y la Innovación (DDI); Spanish state-owned company for the development of design and innovation.

PROJECT:
Corporate identity.

2

3

"El diseño es un proceso en el cual los deseos o necesidades representan el problema, mientras las ideas representan posibles soluciones."
George Nelson

"El diseño significa proyecto, no forma."
Lucius Burkhardt

"Diseño es antes que nada una actitud."
Roger Tallon

"Diseño son conceptos e ideas antes que abstraccion o decoracion." Robert Brownjohn

"El Arte son cosas feas que se vuelven bellas, y Moda son cosas bellas que se vuelven feas."
Coco Chanel

1

Mario Eskenazi:

"I don't go looking for clients—they come to me. I approach all of my projects the same way. For me the most important thing is the project, not the client. In this case, the client was a state-owned company based in Madrid that is dedicated to the promotion of design in Spain within the design community and to executive directors of Spanish enterprises—the equivalent of the Design Council in the UK. They realized that their corporate identity, which was created when the company was established 15 years ago, was outdated. I was approached by the managing director, who was familiar with my work. She came to my studio in Barcelona to explain her company's needs. The second meeting, this time in Madrid, was my presentation to the board of directors, who unanimously approved my proposal.

1 In the absence of a convincing definition of "diseño," Mario Eskenazi chose quotations about design to form the basis of the identity of the DDI.

2–3 Letterhead and business cards, showing the application of quotations.

"My aim was very simply to inform the audience about design. As I was unable to find a concrete definition of 'diseño'—not even in the official Spanish dictionary—I decided to use quotations from designers and creatives; their thoughts and opinions about design. There was no role for the client after the initial briefing and my proposal was well received. It was my first idea and I was pleased that I managed to retain its simplicity. The identity has been very well received and has generated a lot of discussion, which was my original aim. What's more, a year on from the implementation of the DDI identity, I received a similar commission from BCD—the Barcelona Design Center—which is an organization with the same aims but on a regional scale.

"The client [DDI] is happy and from the first moment felt comfortable with it—the transition from the old identity was painless. I had, and continue to have, a very good relationship with the client; she has now become a good friend. I was given a lot of freedom and there was mutual respect, which is the ideal working situation. The experience reaffirmed for me that a designer should never be afraid to present a strong idea."

4–7 More applications, designed to raise the visibility of the DDI with strong quotes and vivid colors.

DESIGN FIRM:

Inkahoots

CLIENT:
Department of Emergency
Services, Queensland, Australia.

PROJECT:
Public artwork for the Roma Street
Fire and Ambulance Station,
Brisbane, Australia.

Jason Grant, Designer and Director, Inkahoots
"We only occasionally approach potential clients, not because there
aren't plenty who we'd love to work with, but for the usual reasons of
being too busy with everything else. We don't really advertise, except as
part of a broader social campaign, or an email about an Inkahoots event.
Mostly we receive clients who have seen our work.

"We were approached on behalf of the Department of Emergency
Services by Project Services, a government agency responsible for
commissioning and managing public artworks. The Department of
Emergency Services is responsible for the prevention, preparedness,
response, and recovery in relation to emergency and disaster
management through two main services: Fire and Rescue, and
Ambulance. Its purpose is to 'save lives, protect property, and help
preserve the natural environment.' They employ more than 7,700
full-time and part-time employees, and are supported by more than
85,000 volunteers across the state.

1–3 Inkahoots' proposal
for the artwork at the
Roma Street Fire and
Ambulance Station
involved creating a
graphic "skin" for the
building (the Siren Wall)
and a pedestrian barrier
with an emergency light
animation (the Siren
Fence).

"Along with three other artists, Inkahoots were commissioned to submit a concept proposal for a public artwork for the city's central Fire and Ambulance station. Our initial meetings were with the Fire and Ambulance Directors, Department of Emergency Services Facilities Management, Government Architect, and public art project managers from Project Services, as well as firefighters and ambulance officers. For these blokes (and they were all blokes) to value and embrace art and design as a part of their facility was something we appreciated and wanted to respond to.

"The station is located on a prominent corner in Brisbane CBD, next to a major traffic intersection, a busy busway, and railway lines, making the site highly visible to the general public. A walkway links the city's main transit center to a sports stadium, taking up to 50,000 pedestrians past the site on a game night.

4

5

6

"We began with the idea of a colorful graphic 'skin' ('Siren Wall') for the site's western perimeter wall. We wanted the work to reference the services' heritage. After seeing historical ephemera proudly displayed at the station, we began researching the services' heritage, visiting fire and ambulance museums and collecting historical information. We also spent much time researching materials relating to retro-reflective road signs—corrosion-resistant metals, UV-stable inks, varying degrees of reflectiveness, lifespans, vandal-proofing, and so on. We found a terrific manufacturer who helped a lot.

4–5 The Siren Wall under construction, and the finished artwork.　　**6** A development of the Siren Wall's graphic pattern.

"We generated a palette of iconography based on vintage emergency service vehicle sirens. These wonderful modernist industrial designs become timeless geometric symbols when they are stylized as graphic icons. A recurring module motif was developed to enable the coverage of large surfaces with a repeating graphic pattern. We think the client's identification with this approach probably enabled the visual outcome to be more adventurous than it might have been.

7

8

9

10

"Because thousands of pedestrians pour past the site during sporting events, we wanted to create a pedestrian screen/barrier (called the 'Siren Fence') that also functioned as a vehicle warning alarm. We proposed tall steel fins spaced between ground-embedded LED lights that are programmed to illuminate the posts in animated sequences (evoking an emergency response), triggered by the departure of emergency service vehicles.

7–10 Development of icons derived from vintage emergency vehicle alarms.

"The relationship with the client was always good. They were an important part of developing and testing design ideas. For example, we needed to make sure the reflections from such a large bank of signs weren't hazardous or distracting for train and bus drivers and general traffic, and the client was able to coordinate testing and feedback from the relevant organizations. Because the ambulance drivers would be exiting the site via a pedestrian thoroughfare, we needed to check the driver's visibility through the barrier, so we mocked up a section of fence in order to fine-tune the angling of the posts as the vehicle exited.

"The project was our first public artwork of this scale and nature. Most clients have a direct stake in the functionality of the work; here the process was more ambiguous. While we were used to creating visual communication for this kind of client, it was the client's relationship to the nature of the project that was new for us here. If 'art' comes into other projects, it's usually as a vehicle for promotion or education, not as an open-ended creative product. The outcome does have many layers of functionality, but it also has many less tangible qualities that a client whose operating budget is directed at saving lives will not usually embrace.

"The client liked the work because it was grounded in their culture. The referencing of their heritage, and the way we linked it to their contemporary role and then presented it with a vitality and relevance, must have appealed."

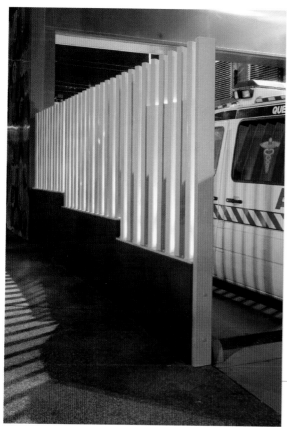

11 Using the alarm icons, a recurring module motif was developed that could be repeated across the expanse of wall.

12 The Siren Fence is lit in animated sequences to warn pedestrians when emergency vehicles are leaving the station.

DESIGN FIRM:
Kinetic

CLIENT:
Wong Coco Pte Ltd.; the export marketing arm of an Indonesian-based food manufacturer, Keong Nusantara Abadi.

PROJECT:
Packaging for range of Jubes Nata De Coco desserts.

Carolyn Teo, Managing Director, Kinetic:
"We count ourselves very lucky, as we've never really had the task of attracting clients. We get a fair number of referrals from our current clients, and whenever we work on stuff we'll put our 'A Kinetic Design' on the piece of work. It means we make sure the project is good enough to make people want to know who did it, and call us.

"In this case, the client was an Indonesian company who wanted us to work on advertising their product. When we looked at it, we felt the product itself had to change for it to appeal to a young, discerning Singaporean target audience. This is why it started as a packaging job, before we did any work on the advertising campaign.

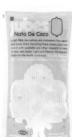

1

2

1–3 Being presented with only one design option for its new range of confectionery packaging—instead of the customary several—took Kinetic's new client by surprise.

"The early meetings were a bit stressful, as the look of the product had to change. The clients were a bit skeptical, but when they looked at the first design and liked it, we never looked back. We found that Singaporeans had a 'thing' for Japanese-style products: that graphical and cute feel. They also wanted to know what they were buying. The limitation with the project was that, although we could change the design on the pack, we couldn't change the actual pack design, as that would have required new production processes.

"For any project for Kinetic, we believe in presenting only one idea. There is no way you can believe in three different concepts at the same time. Ten ideas can be conceived, but we have the practice of questioning all designs till we decide which one would work exactly for the client. That can be a challenge, since agencies in Singapore are known to offer too many options. It was tough at the start when we told the client we would give them only one option, but after they saw the concept, everything moved on really quickly and smoothly."

3

Pann Lim, Creative Director, Kinetic:
"Jubes Nata De Coco is made from coconut. It's juicy and chewy and comes in the shape of a cube. Sean Lam, our interactive creative director, came up with the name 'Jubes,' which derives from the words 'juicy' and 'cubes.' We created a character, or mascot, with a huge mouth through which you can see the 'cubes.'

"The packaging also included copy with the nutritional facts (high-fiber and cholesterol-free) of the product. Even the range of fruity flavors was shown with cubelike illustrations of the fruits."

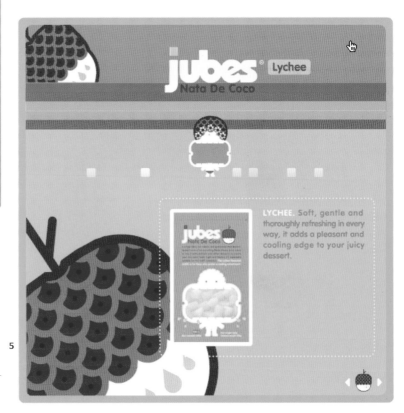

4

5

4–6 Packaging for different flavors of the Jubes desserts.

Carolyn Teo, Managing Director, Kinetic:

"The use of the colors of the fruits helps the customer identify the flavor of the product, and the see-through effect shows clearly what's inside. The play of text and colors and icons makes the product look more 'cool' to buy. Also, because we wanted to reach out to children as well, the mascot had to be interesting enough to be used extensively, from the packaging all the way through to the website.

"The project worked out really well for us and for the client. They managed to sell Jubes in retail outlets such as higher-end supermarkets that didn't previously stock their product. Also, they were able to price the product 40% higher, and captured a target group they previously didn't have. People were more open to trying the product, and they even managed to sell it in other countries on the strength of the packaging design. As for us, we won quite a few awards for Jubes, from the packaging to the website.

"As with all relationships, there are ups and downs. But the key thing is that Kinetic and the client shared the same vision of making the product recognizable and successful.

"I think the secret for us is that we treat our clients as our partners. This is easier said than done in the real world. However, we constantly put ourselves in their shoes and ask, 'If this were my brand, would I still do the same?' Only if the answer is a definite yes do we push the work across. And when a client sees how much you believe in something, things usually work out well."

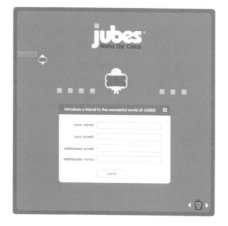

DESIGN FIRM:
Milkxhake

CLIENT:
Ruggero Baldasso Architects
(RBA), Italy.

PROJECT:
Corporate identity.

Javin Mo, Creative Director, Milkxhake:

"We don't do any promotion to attract new clients. New people see our work somewhere and approach us directly, then become our new clients; some may become our friends as well. This process is very important to us. We concentrate on doing good work for our clients and attract more good clients that way. By 'good' clients I mean that they possess good 'content' in terms of their business, and while they may not be strong in design aesthetic, they need to respect the role of a graphic designer. Winning more clients and winning more 'good' clients are totally different things. Winning more 'good' clients can drive the diversity and creativity of the studio.

"We always put our work on our website when we finish projects, and many international design journals and publications have featured our works. We always let our clients know when this happens, and it helps build a good relationship with them.

1–2 The finished RBA logotype and printed applications.

"Ruggero Baldasso Architects (RBA) is an architectural firm; the founder, Ruggero Baldasso, is a very young Italian architect. We knew each other when I was working at Fabrica, the Benetton Research and Communication Center in Italy, in 2004–5.

"Ruggero worked closely with Fabrica on the project development of X-Site, the new city of entertainment in Jesolo, Italy. Ruggero was the chief architect of the project and Fabrica was commissioned to design the identity. My proposal was selected and I worked closely with Ruggero.

"Later, Ruggero commissioned me to develop the new identity of his own architectural firm—RBA. We met up at his studio in San Dona di Piave on the outskirts of Venice a couple of times before moving on to the actual design process. The firm was set up in 1999 and had no concrete identity; the namecard and website were basic designs. Our task was to create a totally new and unique identity for the studio. Ruggero agreed that a solid identity could help in maintaining the relationship between the studio and their clients.

3

4

5

3–5 Further stationery applications.

"The project was mainly targeted toward the architectural community and professionals in Europe, although the studio has also recently completed projects in China. They needed a strong and simple identity to convey the studio's philosophy, to promote convergence in the architectural community. Their vision was to create a strong architectural network connecting different professions, rather than merely running the studio. This 'belief' became the most important element of the new identity. We developed ideas on how to evolve not merely a logo, but concentrated on building a solid visual identity that could be extended in the future into other platforms.

6

"Ruggero gave us lots of reference points for typography, stationery, and some interesting logotypes that inspired him. We studied these together and discussed how far we should go beyond a generic, singular architectural identity. The whole process went very well. We would discuss the project either in his studio or at an Italian restaurant, and our shared perception of the studio's philosophy led to a very smooth creative process.

"I was deeply impressed by the architectural models in Ruggero's studio and thought it would be great if they could be transformed into a logotype. That inspired the development of a system of architectural 'blocks.' I made studies on various 'block' shapes and how they could convey the idea of 'connectivity' in the logotype.

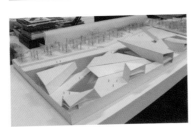

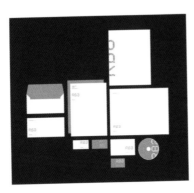

7

6 Development of the logotype, from a system of architectural "blocks" through to a finished design, intended to express the notion of connectivity.

7 The RBA studio, with a typical architectural model; draft business card designs; and the finished suite of stationery.

"In the early stages, we proposed different logotypes comprised of blocks and different possibilities of shapes and forms. The final logotype consisted of different tiny blocks, generating structures that represent the architectural community. It provided a visual theme for all the applications, from stationery to the website.

"The identity has received good feedback from the architectural community in Italy. It was also awarded a Bronze in the Visual Identity category at the Graphic Design in China 2007 awards, and has been featured in international design journals."

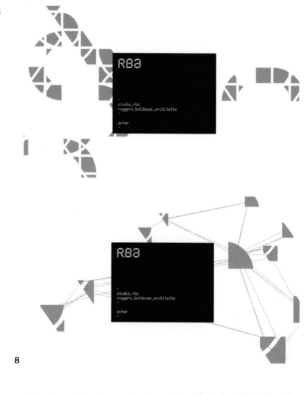

8

9

8 Development of the RBA website, with the logotype as an animated background.

9 Pages from the final website, in which the movement of the visitor's mouse highlights architectural blocks at the base of the page.

DESIGN FIRM:

Number 17

CLIENT:

A property development consortium of three companies: Montagu Square Development, Douglaston Development, and Corcoran Group Marketing.

PROJECT:

Identity, collateral, website, signage, and advertising for the Zinc Building, Tribeca, Manhattan.

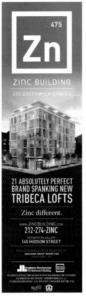

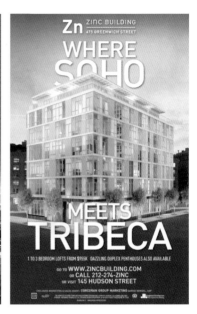

1

Bonnie Siegler, Chairman, Number 17:

"We have no idea how we attract new clients. All of our clients are referrals from other clients or from people we have met in the course of doing business. The Zinc Building is a perfect example of this point.

"We traveled to New Jersey (I happened to be eight months pregnant at the time and it was a HOT day) to present our work to about ten people and discuss potentially designing collateral for a new development in New Jersey with views of Manhattan. We didn't have enough real-estate experience for this group, so we didn't get the job. However, six months later, someone at that meeting remembered us when he was working on a new, smaller project in Manhattan—one that we'd be perfect for. In this case, the clients were intrigued by our lack of experience. They thought we would bring a fresh eye to this kind of work. So what was seen as a drawback before became an asset for this project.

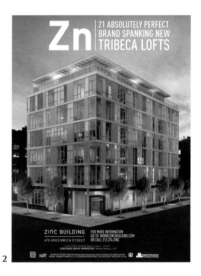

2

1–2 Advertising and marketing material for yet-to-be-completed properties usually has to make the most of visualizations instead of photography; so it was for the three campaigns for the Zinc Building in Tribeca, Manhattan.

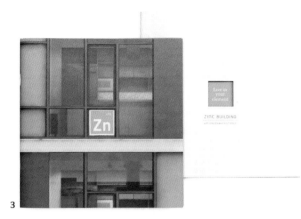

3

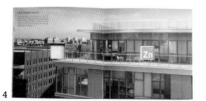

4

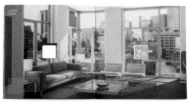

"The clients liked the work and liked how we spoke about what we do. Also, the building is a bit unusual—they called it a sassy little building, and they perceived us as a sassy little design studio.

"The development was a ground-up, small (by Manhattan standards), new luxury condominium in Tribeca. They needed a name for the building, a logo, brochure, website, signage, advertising, and the design of the sales office. The audience was people who wanted to live in Tribeca; mostly young professionals purchasing their first or second apartment or people starting families. They also had to be people who could visualize what the building COULD be since there was no actual building to walk around in yet.

"Our office is in Tribeca (and has been for 15 years), so we knew the neighborhood and we knew what people like about it and how to talk about that. We have done some real-estate work so we understood our client's concerns and how to talk about that. But primarily we are New Yorkers, and as such we are personally, as well as professionally, obsessed with real estate. Between the two of us [Bonnie and Emily Oberman, Number 17's chief executive], we have bought and sold five apartments. We are very familiar with the environment and what people respond to.

3–4 Number 17's square logo provided the central element and format of the sales brochure.

"There are many new developments in Tribeca. This was one of the smaller ones, and had the unique quality of being a new building in a district of cast-iron nineteenth-century giants. So we decided to embrace the newness while capturing quintessential Tribeca. One of the ways we did this was to hire an amazing photographer, Luca Vignelli. He has an incredible eye and every picture he takes makes the neighborhood seem extra-special and beautiful.

"The campaigns went through a few evolutions, beginning with the 'Brand Spanking New' campaign. Then, in response to feedback from potential buyers about the location, we came up with a new campaign: 'Where SoHo meets Tribeca.' Finally, we came up with 'One Dazzling Penthouse Left.'

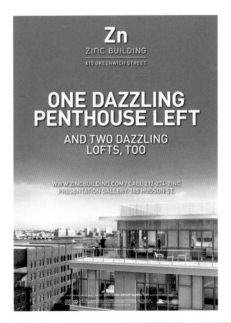

"In a boutique building like this, details are extraordinarily important. We took that to heart with the design and paid extra-special attention to every detail. That way, even if a potential buyer saw only the floorplan or a single sign or a single ad, they would understand the brand as a whole.

"The logo we made out of zinc's 'box' in the periodic table of elements. '475' comes from the street address, 475 Greenwich Street, so we made it look like its elemental number.

5 Three alternative logos, and the final design. 6 Further advertising, and site signage.

7 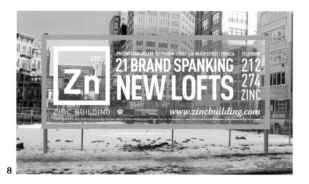 THIS CONSTRUCTION SITE WILL BECOME 21 ABSOLUTELY PERFECT, BRAND SPANKING NEW LOFTS. | GO TO www.ZINCBUILDING.COM OR CALL 212-274-ZINC FOR MORE INFO.

8

9

"The idea behind the see-through site sign was that everyone likes to look at construction as it happens. And in time, the building would appear 'in the sign' as though we'd put a photo in the background.

"When we're working with new clients, we try to get as much information as possible from them: likes and dislikes, hopes and dreams, specifics about their industry and their competition. And this wasn't just one new client, it was three: the realtors, the developers, and the property owners. We met with all of the clients once a week for the duration of the project: we had a room of between eight and twelve people every week. We all seemed to share a vision for what the personality of the building should be. We presented work every week and then talked about it in a very open and collaborative way. Sometimes there would be a strong opinion from one of the clients that we didn't agree with, but mostly we all felt the collaboration was a good one.

"Everyone had the same goal with different interests along the way, and we had to respond to all of them simultaneously. But we were lucky because everyone agreed that the design and the personality we projected were crucial to the success of the building. With our common goal we worked well together and grew to trust each other's insights over the life of the project. And they were all really good at their own jobs. That is what really made this project successful.

'All the apartments sold and everyone was very happy with the process. We felt we would have worked with these people again in a heartbeat, and we have done since."

7 Site signage.

8 A transparent site hoarding framed the property as it was built.

9 Pages from the sales website, featuring photography of the Tribeca district by Luca Vignelli.

As Mario Eskenazi says in introducing his work for the antiracism charity, Fundación Lilian Thuram (FLT), the challenge of designing for a good cause is, on the surface, not much different to that of designing for a corporation. It is still to find a powerful, innovative solution and deliver it to the best of one's ability.

This, to many designers, must seem like saying that the challenge of reaching a destination by bicycle is the same as that of reaching it by high-speed train. The typical project for a charity or good cause is a markedly different experience from the standard corporate assignment. The worst case will involve an inadequate budget for implementation, an indecisive, chaotic client side, and interminable approval processes. On top of it all will be a client who secretly resents having to hire a design company in the first place and loses sleep over the necessity of adopting the same kind of commercial brand communication techniques as their loathed corporate cousins.

THE GOOD CAUSE

None of the projects featured here fit that nightmare stereotype. These are, for the most part, causes and clients that conform to the more conventional mold, involving a high degree of creative freedom in return for small financial gain and significant moral reward. Of course, good causes tend to embody ideas and ideals that designers are naturally drawn toward, not just because they are worthy, but also because they render unnecessary the search for meaning that is a ritual first step in the design of an annual report or corporate brochure. The causes addressed on the following pages require no special level of empathy or interpretation; they include climate change, racism, domestic violence, southern hemisphere debt, and the aftermath of 9/11.

For some of the designers here, the affinity to their cause—and their response to it—is deepened by a personal involvement. Mario Eskenazi, a Jewish immigrant working in Spain, was an inspired choice of designer for the FLT. Number 17, based in offices just a few blocks from Ground Zero, were able to trust their emotions and instincts in designing material for the National September 11 Memorial and Museum. And Milkxhake didn't wait for a client such as the Hong Kong Tourist Board to commission a campaign to help see islanders through the SARS crisis; they did it themselves.

Even without personal attachment, good causes can elicit powerful ideas from designers. Browns' conception and creation of a lavish hardback book and international traveling exhibition won The Climate Group yards of press coverage around the world and a place in the consciousness of global businesses and governments. At the other end of the budgetary scale, Kinetic's posters for Singapore's Center for Promoting Alternatives to Violence are nothing short of mesmerizing.

DESIGN FIRM:
Browns Design

CLIENT:
The Climate Group;
a UK-based international coalition
of governments and businesses
committed to finding solutions to
climate change.

PROJECT:
Naming, corporate identity,
and *North South East West*,
a promotional book and
traveling exhibition.

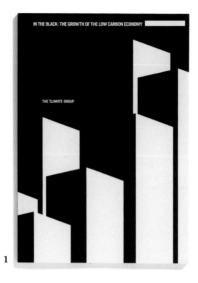

1

2

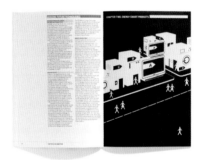

Nick Jones, Partner, Browns Design:
"The Climate Group came to us in 2004 via a referral from an ad agency that Jon [Ellery] knows. They were four people, a breakaway group from WWF who wanted to do something to combat climate change. Their key audience was people in power: politicians, presidents, prime ministers, chief executives, editors, and so on. They were clear that they shouldn't be all gloom and doom; they were going to take a practical, collaborative, solutions-based approach. They wanted to concentrate on ways of investing in emissions reductions that could offer business and governments a payback in terms of financial savings and goodwill. They were a not-for-profit group, and not aligned to any political party.

"We were asked to develop an identity and a basic stationery system. First, we looked at other possible names. In the end, though, given the audience we were targeting, we decided not to try to be too cute, and we stuck with The Climate Group.

1–2 A typical publication from The Climate Group, showing the use of powerful typography and a strident palette to escape the conventional look of campaigning environmental literature

3

"The identity was one of those that came in the first hour, like a gift from the graphic gods. It was universally understood. The red degree mark next to the 'C' of 'Climate' hinted at a hot planet, as well as at the scale of the temperature rise. In an area that is crowded with blue and green and wobbly pictures of planets, it stands out. Even though the group is not political, we felt quite strongly that the use of purely red, black, and white would help give a sense of clarity, and a sense of warning, too.

"Up until now, we've been able to develop their identity without guidelines; we've been the only ones doing communications for them. As they have grown—there are now 30 people there—and developed a personality and tonality they are comfortable with, we've been able to evolve the visual language to fit.

"Funds have been an issue, but we tackled that by, for example, designing documents to make the most efficient use of stock paper sizes. We're also aware of the perceived contradiction of producing paper documents for an environmental organization. Awareness of climate change now is much higher than it was, even in 2004. Then, the value of raising awareness with a publication far outweighed the impact on the environment.

"The group had a very high-profile launch at the Banqueting Hall in Whitehall [London], with a speech by Tony Blair. A year or so later, they were going to meetings with prime ministers, presidents, and CEOs and needed something to use as a 'leave-behind'; a reminder of what the problems are and what the solutions could be.

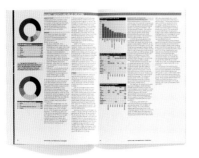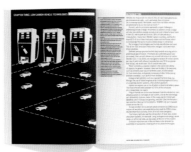

3 A degree of difference: Browns' logo for The Climate Group.

4

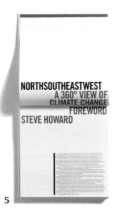

5

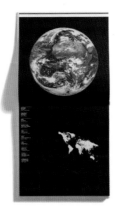

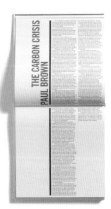

"We developed the concept of a book: the most complete audit of climate change produced to date, focusing on ten climate change stories in ten locations, photographed by ten Magnum photographers, and with contributions from ten international figures. We're passionate about books, and we've helped to produce several with Magnum before.

"We identified the stories, shot the images, and commissioned commentary from Paul Brown of [UK newspaper] *The Guardian*. There was a lot of editing to do; we had 3–5,000 shots for a book of 130–150 images. We had to balance the quality of the shot with the degree to which it connected with the theme. Lots of great images had to be cut.

4–5 Cover and spreads from the lavish "North South East West" book, featuring images of ecological hotspots around the world by ten Magnum photographers.

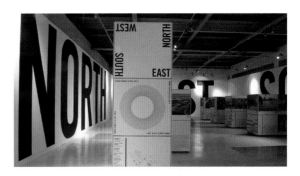

6

"Around that time, The Climate Group was crossing over to talk to the person in the street more, on the basis that public pressure would have an effect on business and government. To achieve that, we suggested an international traveling exhibition of the book, which we called *North South East West*. That was an enormous exercise; designing, building, and transporting a modular exhibition—a kit of parts—that could shrink or grow to almost any size. It's been a logistical exercise as much as a design exercise, checking venues and permissions and government regulations in every country. So far, the exhibition has been to around 120 cities in 50 countries and has been seen by about seven million people.

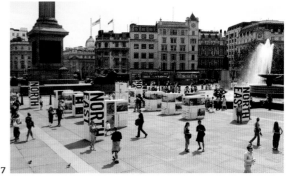

7

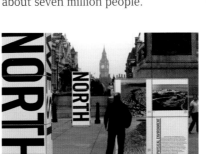

"What this project shows is an intellectual, conceptual approach to what design can achieve for an organization. That's something we try to bring to clients. Not many design companies would have suggested, let alone tried to realize, a traveling exhibition on this scale as a way of reaching the international public."

6–7 The traveling exhibition of the book, at the Science Museum, London, and in Trafalgar Square, London.

DESIGN FIRM:

Coast

CLIENT:
Eurodad; a European network of nongovernmental organizations working on issues related to debt, development finance, and poverty reduction.

PROJECT:
Campaign materials.

Fred Vanhorenbeke, Partner and Creative Director, Coast:
"We have always designed for good causes, which, for us, includes doing free jobs for young entrepreneurs in music and fashion, where there is not always a budget. Some young entrepreneurs and fashion designers live in poverty. We like the idea of helping people locally as well. Designing for a 'good cause' is now very political. Every advertising agency needs a 'good cause' project today; it looks good in their portfolio. We don't do enough of it because of a lack of time. Also, we need to preserve our financial balance; doing too many free jobs can be dangerous for a small studio like ours.

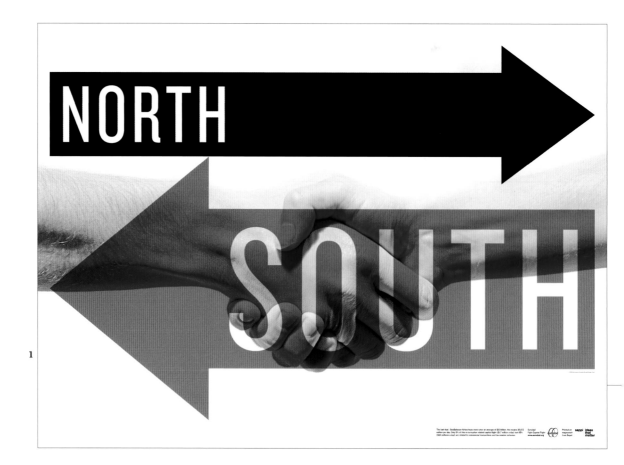

1

2

3

"Eurodad (www.eurodad.org) is a network of 54 NGOs in 16 European countries working to change development finance policies and ensure that poorer people have an influence on decisions that affect their lives. The organization's work concerns debt and the aid accorded to poorer countries. They work to have debts lifted and to inform governments on their financial policies.

"We got involved with the organization through a 'design for good' program launched by the paper producer Sappi. We knew Eurodad because they were based in our old offices, and we approached them to help develop a communication tool within the framework of the program. They were very enthusiastic because they wanted to promote their new campaign about 'capital flight' (international money laundering) from South to North. They were also getting our services for free. Since there was no money changing hands (due to Sappi's support of the program), the project was free of budget concerns.

1–3 For Eurodad, which campaigns to reduce international debt, Coast developed a box of campaigning materials to be sent to potential supporters. The posters, shown here, and other materials, used hard-hitting graphics to highlight the issue of capital flight from southern hemisphere countries to the northern hemisphere.

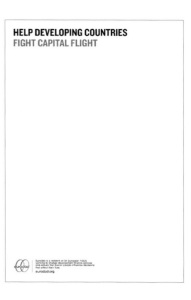

HELP DEVELOPING COUNTRIES
FIGHT CAPITAL FLIGHT

4

"All Eurodad gave us to start with was a poorly designed report, titled 'Capital Flight Diverts Development Finance.' The target group was economic policy-makers in Europe, so we promised to develop something that would increase Eurodad's visibility and raise awareness about capital flight among those people.

"We decided to create a Eurodad fact box: a cardboard box containing a set of postcards on the subject of capital flight, the report (redesigned by us), a set of posters, and a book. This allowed Eurodad to send either the whole box or separate elements to decision-makers.

5

4 The box included a set of postcards, each offering a precise visual interpretation of a capital flight fact, with the fact itself or a slogan on the reverse.

5 The box used to package the Eurodad materials.

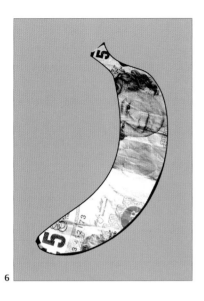

THE PRICE OF A £1 BANANA: HOW
BIG CORPORATIONS CUT THEIR TAX
Many transnational banana companies use tax havens
to cut their tax and increase their profit. This is a
summary of banana costs after a long journey into tax
havens:

Step 1: Banana leaves Latin America: 13p (1.5p labour
cost, 10.5p production costs, 1p taxable profit)
Step 2: Cayman Islands: 8p (purchasing network)
Step 3: Luxembourg: 8p (financial services)
Step 4: Ireland: 4p (use of brand)
Step 5: Isle of Man: 4p (insurance services)
Step 6: Jersey: 6p (management services)
Step 7: Bermuda: 17p (distribution network)
Step 8: United Kingdom: 40p (1p in taxable profit + 39p
retailer profit)

eurodad is a network of 54 European NGOs
working to change development finance policies
and ensure that poorer people influence decisions
that affect their lives.
eurodad.org

6

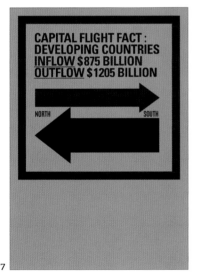

HELP DEVELOPING COUNTRIES
FIGHT CAPITAL FLIGHT

eurodad is a network of 54 European NGOs
working to change development finance policies
and ensure that poorer people influence decisions
that affect their lives.
eurodad.org

7

"We wanted to display facts visually, and allow these visual elements to be used online, or at events. It was important to get these facts across strongly. The economic gap between North and South is due to several factors, and one of them is capital flight. For each dollar that goes to the South in aid, more than $7 comes back to the North through illicit proceeds.

"The book was called *563 Names Under Two Dollars Forty-Five* and featured the names of 563 people working for less than $2.45 on a banana plantation. The book is full of names. It shows the accumulation of poor people working for large-scale enterprises on small salaries. The names are made up, but the facts are real. Banana workers receive 1% of the final product price in Europe, while the companies receive more than 40%, using tax havens to reduce their tax.

"For most clients, our design is style-based or involves subtle, client-driven ideas. This was different: we had to come with more 'in-your-face' ideas that would make a point in a hard-hitting way. For us, graphic design for corporate clients usually involves making things look good without worrying too much about content. Designing for good made us think more deeply as content creators."

6–7 Further postcards.

DESIGN FIRM:

Mario Eskenazi

CLIENT:
Fundación Lilian Thuram (FLT); a Spanish antiracism charity founded by former French international footballer, Lilian Thuram.

PROJECT:
Corporate identity and applications.

1

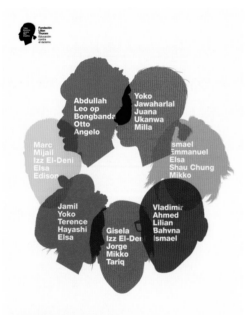

**Todos iguales
Todos diferentes**

2

Mario Eskenazi:

"I don't do as much work for charities as I would like to. Most local charities don't rely on professional designers for their graphic design. I find this kind of work very rewarding, because it feels like something that is directly useful to society. Overall, the challenges are the same as with any other project: to do one's best work, to find innovative graphic solutions, and to establish powerful emotional ties.

"At a strictly professional level, it's not very different to work for a client that is a charity as opposed to a corporation. There's a problem that needs a solution and there's a design process. One finds a solution, it's presented and explained, then implemented. Perhaps the main difference lies in the client's understanding of the design world—there's a greater level of subjectivity, for instance, in their assessment of the proposals. But it's never a real problem once things are explained. In the case of Fundación Lilian Thuram (FLT), the director Marc Dolade had a marketing background with Médecins Sans Frontières [Doctors Without Borders]. Before joining FLT, he worked at the advertising agency DDB, which advised Lilian Thuram in the creation of the foundation. In fact, it was Marc Dolade who got in touch with us to work on this identity.

1 The identity expresses the idea of all individuals being different yet members of a single race—the human race.

2 Poster.

3

4

"Of course, the fees are very different when working for charities. They generally work on a tight budget. These are projects that one does not do for the money. In this case, for instance, we charged a symbolic fee defined by the client.

"This was my most intense experience in the charity field, and therefore the best one. It's the only one (alongside Sida i Societat; see pp. 142–145) where I started from zero and followed the project through to the very end. Both projects were designed in collaboration with Diego Feijóo, who was then my assistant.

5

3 Business cards. **4** Envelopes. **5** Letterhead variations.

6 **Fundación Lilian Thuram**
Educación contra el racismo

"FLT seeks to fight racism through education. Its tagline is 'Educating against racism.' It organizes courses for schools, arranges seminars, creates libraries, and so on. FLT is a private foundation financed by the French footballer Lilian Thuram. He was born in Guadeloupe and moved to Paris when he was a young boy. He lived in the suburbs of the city and experienced racism at first hand. The foundation was established in Spain because Lilian had been a player for FC Barcelona and was living in Spain at the time.

"The fight against racism is one that is worth fighting for as a universal cause (just like sustainability, for instance), but I also feel very strongly about it at a personal level—both as a Jew and as an immigrant.

7

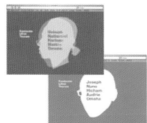

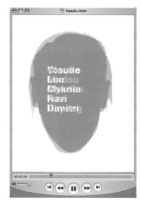

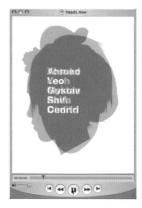

6 One permutation of the FLT identity.

7 A guide to the visual identity and website pages.

8 Stills from an animation of the identity.

9

Der-Jen
Jana
Fyodor
Leo
Alfred

Shanhon
Umar
Rosiska
Lilian
Antoni

Claude
Madou
Charles
Ivan
Hayeng

"FLT needed visibility and personality, and to be distinguished from Spain's other antiracism organizations, such as SOS Racismo. There wasn't really a brief; they just needed a strong identity. Their brief came down to one very powerful idea: there is only one race, the human race. They asked us to design the stationery and the symbol.

"We started from the 'one race' idea. This led us to think that members of the human race can have an infinity of names, silhouettes, colors, and that any individual, therefore, can have any name or appearance without it being something that defines them as belonging to a specific 'race.' The final design brings together a variety of silhouettes and names in a range of different colors, in many combinations.

"The working relationship with FLT was very comfortable and enjoyable throughout the project."

10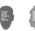

Krishna	Joss	Mañao	Layi
Lyonis	Murtadi	Lorianne	Su'ud
Haytham	Marruki	Muti	Gyasumdo
Abbot	Killien	Chigorin	Sugey
Andreu	Llancapan	Domiku	Jalitman
Momoka	Toyo	Azim	Kaumudi
Chad	Sagbay	Casandra	Perrin
Hemadri	Estel	Agnes	Ezequiel
Goliat	Dinorah	Bhavesh	Kerry
Damian	Athos	Robbie	Tomoki
Ayumu	Rykuto	Albà	Suhayl
Mash'al	Edith	Eleazar	Miku
Neus	Gonçal	Fu'ad	Henriot
Ameline	Sidi	Azubeli	Evens
Aaric	Guaiquil	Ayelen	Andoni
Anatoli	Said	Abdelkalar	Kutúvoz
Kurt	Murtadi	Akatura	Lenny

9–10 Typical "heads," and the four-step process of their creation.

DESIGN FIRM:

Inkahoots

CLIENT:
Memefest; an "international festival of radical communication," held in Slovenia.

PROJECT:
Visual identity and promotional materials for the 2007 festival.

Jason Grant, Designer and Director, Inkahoots:
"Inkahoots is involved with Memefest as a jury member and shares its goal of encouraging an alternative design culture. The name of the festival is taken from the theories of memetics pioneered in the 1970s and later developed in books such as *Media Virus* by Douglas Rushkoff. A meme is a kind of cultural gene that spreads contagiously through communication networks—a viruslike idea that passes from person to person and can breed in the fecund ecology of the mass media.

"Too much of a designer's energy and talent is squandered on spreading exploitative commercial messages. So our friend Dr Oliver Vodeb founded the organization in order to 'nurture and reward innovative and socially responsible approaches to visual communication'—to foster more positive and beneficial memes.

1

1 Final poster for the 2007 Memefest festival, designed by Inkahoots.

"Oliver asked Inkahoots to create the 2007 festival identity to be applied to posters, T-shirts, and the website. It would also be applied to a range of print materials including stickers, fliers, and certificates.

"Every year participants are asked to respond to an academic or culturally critical text. This is usually a book extract, but this year's 'text' was the movie trailer for Alfred Hitchcock's *The Birds*.

2

"We approached the brief as if we were participants ourselves and responded to the Hitchcock trailer. The film is remarkably independent of the movie, and a million miles from contemporary trailers, which are usually just a focus-group-tested clutter of edited movie scenes. In the film, Hitchcock himself wanders around talking to the camera about the way we humans cherish the bird (we cage them and keep them out of the harsh sun, we wear their feathers in appreciation of their beauty, and so on). It's a funny and damning parody of our ignorance and ecological myopia—and a trailer for a blockbuster film! The power of innovative communication is right there.

"For the poster, the audience is mainly communication students as well as designers, artists, and media activists, but also the general public. It is a highly critical and visually literate audience. But we would ordinarily assume that all our work is received with a high level of sophistication anyway. That's not to say that the nature of different audiences' criticality is all the same, but that we wouldn't initiate a condescending discourse. This poster wants to be beautiful and meaningful—just like most people.

2 Stills from the trailer for "The Birds," the cultural item to which festival participants were invited to respond.

"The poster's purpose is to promote the festival, and to publicly raise the issues suggested by this year's theme: 'What is the relationship between man and nature in a world of media spectacle, advertising cool, cynicism, and design fetishism?'

"Our response distills an ancient idea—the interrelationship of humans and nature—but it comes at the beginning of an astounding new chapter of history when it seems we might finally act as if our survival depends on this emerging shared understanding.

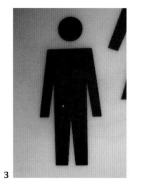

3

4

"We wanted to focus on the folly of assuming we can somehow endlessly exploit and plunder without harming ourselves. But it needed some humor and a simultaneous degree of ambiguity. We had designed a version of the central icon for an early studio website that accompanied the statement 'us = them.'

3–4 Inkahoots created a central icon for the festival identity to symbolize the interdependence of nature and mankind, based on the classic isotype symbol system.

5

6

"This symbol seemed right considering the international reach of the project and the need to engage with so many different cultures. The festival's participants are from every continent on earth, so we imagined a diagrammatic image such as the Pioneer space plaques, with information about humanity not for interception and decoding by extraterrestrials in the future, but for fellow humans now. This simple symbol is then contrasted with more open imagery that is suggestive of the festival's themes.

"I suppose it aspires to the condition of all our work. It's design that is about 'feeling' without being anti-intellectual, and is adventurous both visually and socially.

"Feedback has been very positive. Apparently people are keeping the posters and hanging them on their walls, which is more than you can ask of a meme."

7

5 Feathers became part of the identity, hinting at the festival's theme.

6 The plaques placed on board the Pioneer space probe in the 1970s were part of the inspiration for the main icon.

7 Graphics from ageing Letraset sheets were added to the mix.

DESIGN FIRM:

Kinetic

CLIENT:
Center for Promoting Alternatives to Violence (PAVe); Singaporean charity campaigning against domestic violence.

PROJECT:
Awareness poster campaign.

Pann Lim, Creative Director, Kinetic:

"At Kinetic, we work on roughly one or two charitable projects per year. We are always keen to do more as long as we can squeeze them into our schedules.

"Some of these organizations are tagged on to too many other associations or government bodies, and that can make their decisions on projects very boring, sterile, and safe. But most of the time, creating work for charitable organizations gives us the greatest satisfaction. It is the perfect combination of producing creative work and helping the needy. It's not about making money for once; it's about giving back to society, using our skills and talents for the greater good.

"Of course, cost will always be an issue as we have to work from nothing. I look at this as a challenge. We pull in vendors, photographers, and collaborators who are keen to give back to society without asking for payment.

"There is the challenge of selling creative ideas to clients who do not really understand design and advertising. Most charitable organizations do not have a marketing department, and they tend to think that 'brave and nice' ideas would be damaging to their image.

"Domestic violence is a public issue in Singapore. The government has been instrumental in setting the pace for legal changes and programs for victims and perpetrators of violence. PAVe was set up in response to the need for a more coordinated, holistic, and specialized approach to managing family and interpersonal violence cases.

1

2

1 "Lost Wife" poster, one
of a series designed by
Kinetic for Singapore's
Center for Promoting

Alternatives to Violence
(PAVe). Each poster
featured a victim's story
of domestic violence.

2 "Lost Husband" poster.

"We had a friend who was a victim of family violence and we tried to talk to him. We realized that it's quite a common thing to happen in families, but most of the time the victims are silenced by shame and love, so they usually keep quiet about their plight. Our friend was seeing PAVe, and that is how we found out about the organization.

"PAVe needed to raise awareness of both the issue and of their organization. They asked us to produce a series of posters to be placed in public areas and collateral for their roadshow. The brief was to lead the victims to help and to make them feel that they are not lost.

MAZE

Maze is a set of alphabet and typographic lexicon designed specifically for PAVe, Centre for Promoting Alternatives to Violence.

It is used in the creation of a series of posters on victims of domestic abuse, depicting their pain and confusion as if they are helplessly lost in a maze.

Alphabets

ABCDEFGHIJKLMNOPQRSTUVWXYZ

Numeric

1234567890

Punctuation

&%.,""[]()-&#?!;

Structure

The letterforms of the typeface are effectively mazes, whether they are on their own or typeset together.

The letterforms are simply individual building blocks that can form a functional maze of any size or magnitude.

Application

Posters created for PAVE, Centre for Promoting Alternatives to Violence, using the Maze letterforms.

Lost Husband

Lost Wife

Lost Child

3

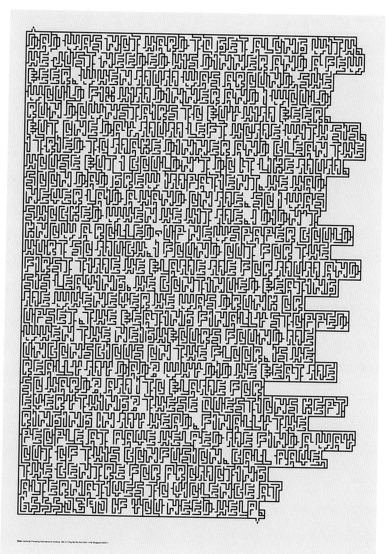

"We created a series of posters targeting different family victims: Lost Husband, Lost Wife, and Lost Child. Our art director Jonathan Yuen devised a font that looks like a maze. When the text about an abused father or mother or child is set in the font, it forms this massive maze that looks very confusing; the feeling you get is really of being lost. But if you examine it closely, there is a way out, and that's where PAVe comes in: to show people the way out.

"The best experience for us was the response the project garnered. The client called and said how well the posters have worked for them during roadshows and so on. There has also been an increase in people calling in for help after seeing the campaign. They have people who have said they called in after reading the posters, or knew someone who was experiencing domestic violence but was previously afraid to ask for help."

4

3 The PAVe "maze" typography, developed by Kinetic's art director, Jonathan Yuen.

4 "Lost Child" poster.

DESIGN FIRM:
Milkxhake

CLIENT:
Self-initiated.

PROJECT:
Hug&kiss identity and poster campaign to raise morale in Hong Kong after the outbreak of SARS.

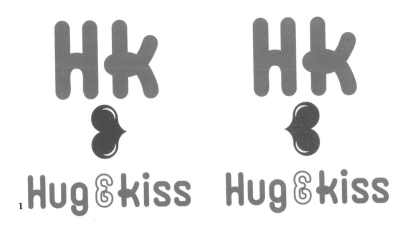

Javin Mo, Creative Director, Milkxhake:
"Hug&kiss was a self-initiated project dedicated to Hong Kong. It was our gift to a place that had experienced the outbreak of SARS in 2003. In Hong Kong, 296 people died of the disease and 1,755 fell ill between March and June 2003. At the height of the outbreak in early April there were 60 to 80 new cases of the disease each day, including among health professionals.

"In such a small city, hundreds of thousands of residents like me wore surgical masks every day. We stayed away from public places in an attempt to avoid catching the virus. SARS strongly affected Hong Kong's economic growth and people were afraid of going out together and socializing. Many shops and restaurants closed down during this period and many people were made unemployed.

1 The Hug&kiss identity was an attempt by Milkxhake to engender a greater sense of community and morale among the Hong Kong population during the SARS outbreak in 2003.

"At that time, we really felt as though Hong Kong people had lost their identity, both mentally and physically. We thought a meaningful identity could help raise awareness of what we all needed at that moment. We created Hug&kiss as a sweet and lovable identity, to cheer people up. We felt that they needed a hug and a kiss during the outbreak, because it was something they couldn't have. A hug and a kiss could spread the disease and infect more people.

"We created the logo in a day. The logo was reversible, and two contrasting and vibrant colors—cyan and magenta—were chosen to give it a refreshing energy. The final design was a sweet new identity for our city and gave the initials HK a new meaning—from Hong Kong to Hug&kiss.

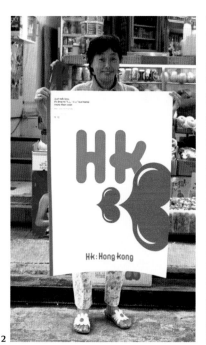 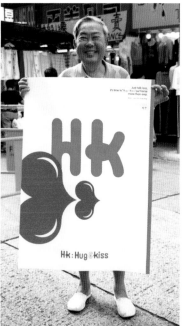

"We wanted to put the idea out on the internet and allow others to use it to cheer up Hong Kong. We put the logo on our site, and on various local and overseas design community webzines and portals to spread the message in a very short time. We also designed a pair of posters that we printed ourselves. We asked two ordinary Hong Kong people to hold the posters and be photographed with them.

"The project received lots of positive comments when we launched it online. We like to think that the identity and our posters helped to cheer people up and get Hong Kong through the crisis."

2

2 The pair of posters, and a pair of cheered-up Hong Kong residents.

DESIGN FIRM:
Number 17

CLIENT:
The National September 11 Memorial and Museum at the World Trade Center.

PROJECT:
Brand identity and collateral.

1

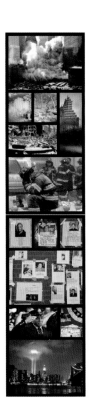

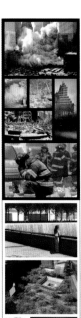

**Think back
and move forward**

Commemorating the victims of the terrorist attacks, the Memorial and Museum will honor those who perished, pay tribute to those who risked their lives to save others, recognize the endurance of those survived, and remember the worldwide outpouring of support.

The World Trade Center Memorial will consist of two massive voids with waterfalls cascading down their sides, a powerful reminder of the Twin Towers and of the unprecedented loss of life from an attack on our soil.

Names of the 2,979 people who perished in the September 11, 2001 attacks in New York, Washington DC, Pennsylvania, and the February 26, 1993 World Trade Center bombing will be inscribed around the edges of the waterfalls.

A landscaped Memorial Plaza will create a contemplative space separate from the sights and sounds of the surrounding city.

Below Memorial Plaza, the state-of-the-art Memorial Museum will offer visitors the opportunity to deepen their experience at the site by facilitating an encounter with the enormity of loss and triumph of human spirit.

Emily Oberman, Chief Executive, Number 17:
"We design all the collateral material for the River To River Festival [see pp. 128–131], which was created after the events of 9/11 to bring people back downtown. They introduced us to the people at what was then called the World Trade Center Memorial Foundation (WTCMF). There had been some collateral produced, but there was a new chairman of the WTCMF, Mayor Michael Bloomberg, and he was interested in creating new material. They looked at the work we had done for other clients and hired us.

"Our work was about creating materials that would raise money to help create the memorial and museum and, more importantly, to communicate what was happening at Ground Zero, what the mission of the organization was, and how our city was going to remember the victims of September 11, 2001.

1 A fold-out brochure, created before the client's name change, the shape of which echoed that of the fallen towers.

"We started out designing a case statement brochure (essentially articulating the mission of the organization) and went on to design a new identity, including the new logo, stationery, collateral, signage, and even a kiosk at Ground Zero.

"While we were working with the organization on the collateral, the decision was made to change the name to the National September 11 Memorial and Museum at the World Trade Center. The name became more inclusive when it focused on the day (9/11) instead of the location (World Trade Center), and since this memorial was also honoring victims from the Pentagon attack and the Shanksville, PA, crash, it was more appropriate.

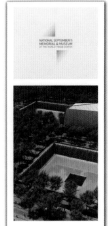

4

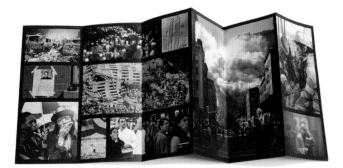

2

"The project was very difficult for us emotionally. Our office is in downtown Manhattan about eight blocks from Ground Zero, so revisiting the day so intensely was hard. We were constantly reviewing images and weighing up the emotional impact of one image over another. You don't want to ever become immune to it, but you also can't relive it day in, day out."

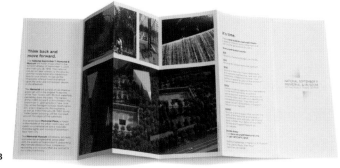

3

2–3 A later leaflet design incorporated the center's new name and identity.

4 Brochure incorporating the revised identity.

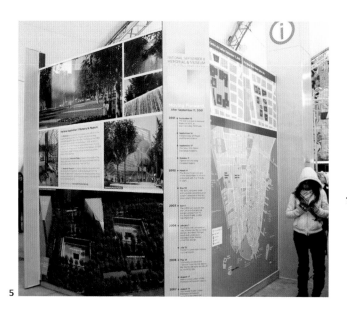

5

World Trade Center
Memorial Foundation
buildthememorial.org

7

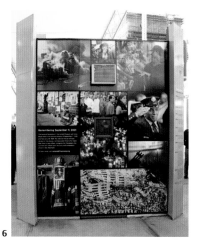

6

"When we began to conceptualize the logo design, we were really daunted by the emotion and the importance of it. But as we all worked and reviewed the work it became a very normal process and we were able to generate a lot of different ideas.

5–6 Kiosk at the World Trade Center site recalling 9/11 and promoting plans for a permanent memorial.

7 Visual identity for the WTC Memorial Foundation, before the change to a more inclusive name.

"Ultimately, the logo they chose is a creative interpretation of the pools of the Memorial itself as well as the footprints of the towers. It also represents the strength and the ephemeral quality of our memories.

NATIONAL SEPTEMBER 11 MEMORIAL & MUSEUM
AT THE WORLD TRADE CENTER

8

NATIONAL SEPTEMBER 11 MEMORIAL AND MUSEUM
AT THE WORLD TRADE CENTER

9

"We were trying to capture the tragic events of the day in an iconic form that would be respectful and powerful. We also had to include the 11 words of the name. We presented about 15 logos to a group from the National September 11 Memorial and Museum. They narrowed it down to about seven, which we revised based on their feedback. The same group narrowed it down to two logos. These were both presented to the chairman, Mayor Bloomberg, and he made the final choice.

NATIONAL
SEPTEMBER 11
MEMORIAL AND MUSEUM
AT THE WORLD TRADE CENTER

10

NATIONAL SEPTEMBER 11 MEMORIAL & MUSEUM
AT THE WORLD TRADE CENTER

11

8 Number 17's new identity for the memorial took the footprint of the World Trade Center towers as its basis, but did not exclude the victims of the other 9/11 atrocities.

9–11 A selection of the 15 logos presented to the client. Incorporating an 11-word name for the organization was a challenge.

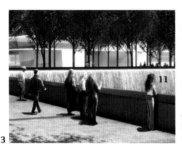

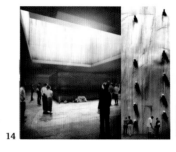

12 13 14

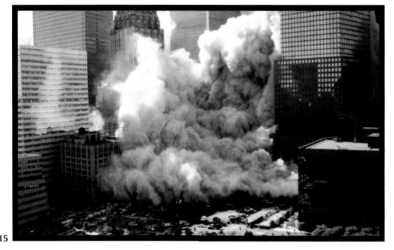

15

The typography has both classic and modern elements to represent the past and the future.

"The scale and complexity and emotion of the project could have overwhelmed our ability to design. But, overall, we really trusted our instincts. One notable example was when we were working on the new case statement. In the original printed piece, a page was devoted to explaining what happened on September 11, 2001. We decided that there were no words to describe that day's events and, besides, everyone in

12–16 Spreads taken from the "case statement," a publication articulating the mission of the memorial and center, incorporating some of the most powerful photography surrounding 9/11.

16

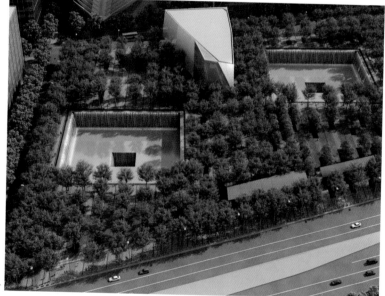

17

the world knows the basic facts and remembers how they felt, so we let the pictures tell that story.

"We became familiar with practically every image of the day and aftermath in existence. Our main source for imagery was an incredibly comprehensive collection of professional and amateur photographs of the World Trade Center disaster that was compiled in a book and exhibit called Here is New York (http://hereisnewyork.org/).

"We are very proud of the work we have done. The client has told us that it has been extraordinarily well received. And there is still lots more work to be done."

17 A visualization of the memorial.

Designers yearn to express themselves. They crave the client who gives them carte blanche. This chapter is about the rare occasion when a design studio is free to write its own brief, and solve a problem according to its own rules. Sounds like the dream job? It's harder than you might think…

Opportunities for a designer to draw freely on his or her own inspirations and ideas in achieving a client's aims tend to come along when his or her demographic matches that of the intended audience. On projects like this, and those in this chapter, there is an instant identification with the target consumer, and no requirement to try to second-guess, through research, market analysis, and testing, the tastes and reference points of a different audience — under-12s, say, or baby boomers.

There are numerous ways in which that kind of creative freedom is come by. Browns convinced Howard Smith Paper that what they needed in order to interest designers in their products was an ideas factory: a source of creative thinking that

THE WIDE OPEN BRIEF

could present HSP, through events, lectures, an award scheme, and publications, as a business with its finger on the design pulse. In conceiving those brand manifestations, Browns simply asked themselves: "What would we want to see/hear/ do/read?"

Mario Eskenazi, over the course of a successful career in which he has conscientiously maintained a small studio, has "filtered his clientele" to include only organizations that can supply him with more open-ended briefs. It was an "act of faith" by Grupo Tragaluz to allow Eskenazi a blank slate in designing identities for its chain of properties. His response was to imagine that each restaurant or hotel belonged to him.

A wide open brief tends to engender that kind of surrogate ownership of a project. The combination of freedom and personal attachment is akin to that experienced by artists. In design, though, however loose the brief, the need remains to channel that impulse meaningfully, and to serve the client's purpose. For Fred Vanhorenbeke of

Coast, there was a new kind of challenge in applying the studio's uninhibited creativity to a book celebrating Belgian nightlife, which was to finish up with "something artistic yet communicative."

Number 17's "labor of love" to create "a cool new product… something we would like to receive" came about at the suggestion of two prominent media acquaintances. It required a significant investment of time and imagination, though, before it took a form that was commercially viable.

If you need more creative freedom than your clients can supply, there is always the outlet of the self-initiated project. For Kinetic's Pann Lim, the urge to provide an antidote to squeaky-clean detergent packaging was rewarded with "pure pleasure," and a final product that no detergent manufacturer anywhere in the world would ever sign off.

DESIGN FIRM:

Browns Design

CLIENT:
Howard Smith Paper;
a paper distributor based
in Nottingham, UK.

PROJECT:
*A British Graphic Design and
Print Landscape 2006*; a book
launching the Howard Smith
Paper Awards, 2006.

Jonathan Ellery, Founding Partner, Browns Design:
"Howard Smith Paper (HSP) is probably the largest paper distributor in
the UK. In 2005, we were asked to pitch for the job of producing all of
their communications—brochures, swatch books, website, and so on.
Basically, their objective was to shift more paper by appealing more to
designers and printers.

"We refused to do any creative work for the pitch. We wanted to address
a deeper issue. What we gave them instead was a series of ideas to do
with raising their profile and gaining credibility, especially among
designers. We won the pitch, based on the strength of those ideas.

1

2

1 "A British Graphic
Design and Print
Landscape 2006" was a
limited-edition hardback
book designed as part of
the relaunch of Howard
Smith Paper's annual
awards scheme.

2 Each spread featured
an uncaptioned
photograph of a UK
design studio—without
the designers.

"What we suggested went far beyond just print, which is our traditional strength as a company. We said, instead of just producing some new swatch books, let's stage a series of lectures by cutting-edge designers, where the attendees receive a book of the designer's work, which happens to contain HSP paper samples.

"The other main strand was an entire campaign aimed at rejuvenating their design and print awards scheme, which had been running for a number of years but had lost credibility among the UK's top design groups. They didn't have any idea of how to engage designers and get the number of entries up. We wanted to make the awards mean more, to give them credibility and to encourage people to enter. We worked with them to get the edit right, which meant refining the judging process: getting the right people on the judging panel.

"To launch the awards and to engage with the kind of design audience we were aiming for, we developed the concept of a limited-edition hardback book and set up a launch event in central London at which the book would be handed out.

"It was a big leap for the company. They were going from thinking about swatch books to a proper book, with the logistics, production costs, and photographers' fees that that would entail, plus a poster campaign, invitations to the launch, and a Warhol-esque event in London, complete with a bar and projections. We had to seduce them with the ambition of it. It was very leftfield, and all very new for them. But they loved it.

3

3 Readers were invited to find clues to the studios' identities in the photographs and match them to the names at the back of the book.

"For the book, we set ourselves the task of engaging designers' curiosity, doing something that was firmly in their universe but revealed something new. So we fed the kind of healthy voyeurism that designers have about other designers' lives and work. We shot the interiors of 25 design studios and four printers' presses from around the UK. There are no captions and no people in the pictures; they have something of the *Marie Celeste* about them. We list the studios at the back of the book, but it's up to the reader to guess which names correspond to which studios. That's classic Browns: that ambiguity, not wanting to give everything to people on a plate.

"At the launch event, we projected the studio images onto three walls, and gave the book away with a call for entries. The book used all the different HSP paper stocks that could make a piece of work eligible for the awards. The standard of entries shot up; the winners' book included studios like Made Thought, Cartlidge Levene, William Hall, and A2/SW/HK. And HSP are shifting a lot more paper now, too."

4

4 The association, through the book, of HSP with leading design groups immediately led to higher-quality entries to the awards.

DESIGN FIRM:

Coast

CLIENT:
British American Tobacco.

PROJECT:
Nightlife; a book to accompany the launch of the website Nightlife.be.

1

2

Fred Vanhorenbeke, Partner and Creative Director, Coast:
"British American Tobacco (BAT) wanted to win the nightlife battle in Belgium: more bars, restaurant, and clubs selling BAT products. For this they wanted a website to create an online community of nightlife places in Belgium were you could find BAT products. The website provided addresses (bars, clubs, and restaurants), nightlife reviews (parties, food, and so on), articles on art, fashion, music (always connected to nightlife).

"We created the overall look for *Nightlife* (logo, website, invitations, advertising) and also the book: a *Nightlife* manifesto. The website launch was held in a photo studio. For the launch we wanted to make the Nightlife concept a tangible object: something people would remember, something that people would keep and show to people, something that would last longer than the project.

3

1–2 "Nightlife" was produced to mark the launch of a website aimed at Belgium's clubbing crowd.

3 The book opens with a series of abstract pages of colors and clouds, evoking a club atmosphere.

"The manifesto is a total Coast proposition (product, concept, authorship, size, material), so the only concerns were deadlines (six months from concept to delivery) and budget, which was €30,000 [US$40,000]. We had to be very kind to all our contributors and ask them for very small invoices! The budget made us opt for a limited edition (1,000 signed copies) and a small format (19 × 23cm/7 × 9in). We preferred a small size with 140 pages to a large book with fewer pages.

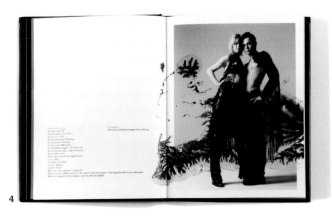

4

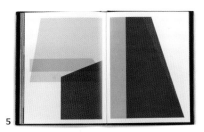

5

6

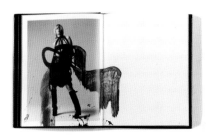

"We had total freedom (except for showing sex or tobacco-smoking), because the client wanted us to create a buzz around nightlife history. They realized that total freedom would express more than restrained design. They knew that when working with creatives (like fashion designer Xavier Delcour, product designer Michael Young, the band Vive la Fête, and various photographers and artists who participated in the book), they would get more by commissioning without restraint. The nightlife crowd doesn't like corporate governance or limits. The challenge was to be able to create something artistic yet communicative.

4 Pages on Els Pynoo from the band Viva la Fête.

5 Pages on furniture (and nightclub) designer Michael Young.

6 Pages created by fashion designer Xavier Delcour and Didier Vervaeren.

7

"This became a very personal project for us. We took the opportunity to express, via artists and people we like, what nightlife means to us. Everything inside the book is a true expression of our thinking, graphic design, and art direction.

"We wrote the rules on the project. For example, previously, the Nightlife website had been called Citygobo. We found the name inappropriate and persuaded the client to change it to Nightlife.be. The Citygobo website was just an address website about nightlife places in Belgium. We turned Citygobo.be into an informative portal on nightlife—like a blog about what's best in Belgium after 7pm.

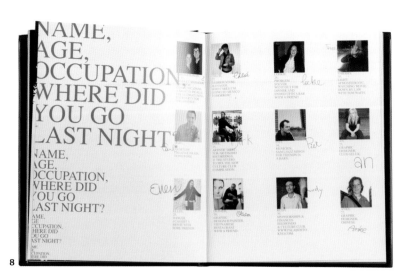

8

7 A section on New York featuring photography by Coast partner and creative director, Fred Vanhorenbeke.

8 The People section offered a vox pop of club owners, DJs, designers, artists, and students.

9

"When you're working for a tobacco producer you also ask yourself if it's good or bad. Deciding whether to work for people selling a product that might kill people is in some ways difficult.

"For us, the project was the starting point of a working relationship with fashion designer Xavier Delcour and the Culture Club nightclub. We had a very positive reaction from the client, and they supported us in the process of developing the book, and in creating the launch party. We participated with them on workshops on branding and completed several other projects following *Nightlife*."

9 Spreads from the
chapters on (l–r)
Undercity, food, and the
website, Nightlife.be.

DESIGN FIRM:

Mario Eskenazi

CLIENT:

Grupo Tragaluz; a Barcelona-based restaurant, bar, and hotel group.

PROJECT:

Restaurant identities.

Mario Eskenazi:

"When I worked in packaging design, most of the briefs from clients were very definite and precise. That is one of the reasons why I eventually stopped doing that kind of work. In the case of corporate identity design, editorial design, and design for cultural institutions, my experience has been that the briefs tend to be much more open-ended and flexible."

1–2 Grupo Tragaluz commissioned identities and applications for several of its restaurants and hotels in Barcelona from Mario Eskenazi, including for Cuines de Santa Caterina.

3 The façade and entrance of Hotel Omm.

"Over time, I have concentrated on that kind of work as it suits my design approach much better. I have also filtered clients based on their willingness to trust my working process from the outset. As a result, most of the briefs I get are open-ended. Because I have a lot of creative freedom in all my projects, they all feel very personal to me.

"In Spain, design is approached in a much more formalistic way than in the UK, Holland, or Switzerland, for instance. Although my clients are unusual, most businesses give out briefs that are quite closed and very similar to each other, put together by their marketing departments. The result is an approach to identity design that is based on producing symbols that can carry a specific kind of value or meaning, such as modernity, solidity, strength, or youth.

4

5

4 Booklet and room directory cover for Hotel Omm.

5 Moo is the restaurant at Hotel Omm. It has its own distinct identity, shown on these menus.

"My working process is quite Anglo-Saxon, focused on concepts, simplicity, and strong ideas. That was a very unusual and shocking approach in Spain 20 years ago, because concepts and simplicity were perceived as betraying a lack of creativity.

"The owners of Grupo Tragaluz, Rosa Esteva and her son Tomas, and their PR manager Carla Emke, contacted me after a series of unsuccessful experiences with other graphic designers. They had exhausted their search for a designer who they felt comfortable working with. In this case, the project came to me as much because of my personal approach to working with clients as my professional profile. I had had quite a lot of experience in designing restaurants, mostly chains of fast-food restaurants: Pans&Company, Cafe di Fiore, and Pastafiori. All of these belong to a Spanish company; Agrolimen.

6 Identity for NegroRojo, which combines Mediterranean ("negro"/ black) with Japanese ("rojo"/red) cuisine.

7 Hotel Omm souvenir products.

"Virtually the only requirement of my work for Grupo Tragaluz was that each restaurant must have a completely unique identity, in the same way as their cuisine and interior design are distinctive in every case. However, there is a conceptual link between all of them, because they are all based on typographical solutions."

9

8

"El Japones was originally meant to be a Japanese restaurant, but changed to a restaurant serving Asian fusion food. So I moved from looking for specifically Japanese sources of inspiration to oriental ideas in general. I came across the I Ching, which is a very structured set of images based on trigrams. I asked one of the restaurant's Japanese cooks to write for me the name of the restaurant in Japanese calligraphy. The result was three signs. This seemed to merge very well with the idea of the I Ching. I also noticed that the name EL JAPONES could be divided into three vertically arranged sets of three letters (ELJ APO NES), similar to an I Ching trigram. Everything fell into place."

8–9 The logotype for El Japones, echoing ancient three-line trigrams of the I Ching system of cosmology.

"The quarterly Grupo Tragaluz newsletter was to feature cooking, culture, and Barcelona events, and was distributed in the group's various restaurants to promote its venues and provide a sense of unity. It was designed with Diego Feijóo, my assistant at the time. It had a reduced budget and used offset paper, two inks, and an A3 [11¾ x 16½in] format.

10

11

"The identity of the newsletter was based on its cover. To encourage the idea of serialization and collectability, I decided to put a very large issue number as the main thing on each cover. Each issue had a different color, plus black. It was meant to be very visual, and the typography of the newsletter eventually became that of the whole group. We chose Rockwell because nobody was using it in the 1990s, so it made it very distinctive and gave it a lot of character.

"The Grupo Tragaluz restaurants are extremely successful. This is partly due to the fact that they are high-profile venues and very fashionable places. But I also think that part of that fashionable status is due to the high visibility of their graphics and visual identities."

10–13 Pages from "Traganews," the group's quarterly newsletter.

DESIGN FIRM:

Inkahoots

CLIENT:
The State Library of Queensland, Brisbane, Australia.

PROJECT:
A set of four murals for the new library building, opened in November 2006.

1

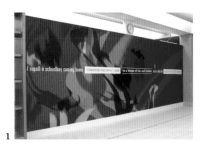

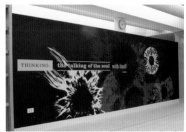

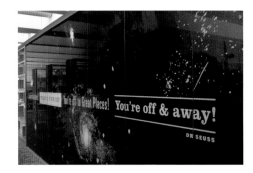

Jason Grant, Designer and Director, Inkahoots:
"The State Library is Australia's leading library of Queensland's documentary heritage and contains major reference and research collections. Our commission was part of an extensive AUD$70 million [US$45 million] redevelopment. It was exciting for us because libraries are among the few truly public spaces remaining—spaces where consumption isn't the imperative or intimation. Even public art galleries are now directly and indirectly fused to the market.

"We were invited to tender with about six other studios and were selected at the end of this process. Initially, the brief was for a series of display walls that presented selected themes from the library's collection, but this was changed to two murals for the main reception areas and two larger murals for the shelving areas.

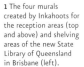

1 The four murals created by Inkahoots for the reception areas (top and above) and shelving areas of the new State Library of Queensland in Brisbane (left).

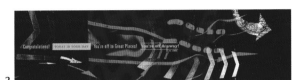

2

"It was really a project in two parts. The original intention was to display carefully curated information and artifacts relating to different themes such as 'poetry,' 'philosophy,' 'music,' and so on, as kind of conceptual entry points to the collection. The final brief, however, was much more open-ended and atmospheric.

3

"Once the client had changed tack and requested a more general approach, we established a new conceptual framework in consultation with the client. This included using a single quote from the nominated theme and a consistent illustrative approach.

2 Alternative designs for the Journeys wall, illustrating a quote from "Oh! The Places You'll Go!" by Dr Seuss.

3 One of the final four mural designs.

4

5

6

"In the first stage, the solutions were fairly complex due to the amount of curated content involved. For example, the 'philosophy' wall presented six quotes from thinkers from different ages and cultures about thinking itself. A custom font was designed and then rendered with a variety of techniques (pencil, linocut, watercolor, felt-tip pen, spray paint, and so on) to suggest unique voices within a unified theme. These would then be applied to large-scale glass panels that visitors could shift along tracks to compose their own mural. For the 'poetry' wall, texts were illustrated then integrated with enlarged versions of original manuscripts. So a poem by Steven Herrick about the school classroom (called 'Poetry') was rendered on stickers and applied to a school exercise book that was then photographed and enlarged.

4–6 Early concepts included the use of multiple quotes for the Philosophy wall, and stickers on an exercise book for the Poetry mural.

"The final solutions were much more straightforward and open-ended, with one quote each supported by an evocative graphic interpretation of the text. For the 'music' wall, for example, we chose a line from one of Brisbane's great bands, the Go-Betweens, as a tribute to their songwriter Grant McLennan, who had recently died. The text is from McLennan's song 'Cattle and Cane' and evokes memories of growing up on North Queensland's sugar-cane farms. The image visually abstracts the phrase 'and in the sky a rain of falling cinders.'

7

"One interesting issue was the project architect's limited understanding of, and faith in, a design discipline that wasn't his own. This meant that visual solutions that were merely optical, symbolic, and flat rather than spatial were dismissed as wanting, as if the power of imagemaking in art and design history had suddenly been transcended by contemporary architectural inspiration. But he did design a great building.

8

"Was there anything Inkahoots-ian about the solution? There probably is a sensibility that is unique to the studio, but we wouldn't want to interrogate it too much. The problem with rationalizing the intuitive aspects of the creative process is that instinct is timid and easily bothered.

"Most people really like the murals, but we guess the architect is still indifferent!"

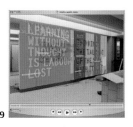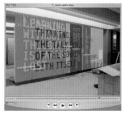

9

7 The final design for the Music mural.

8–9 The earlier solution for the Philosophy mural comprised movable text panels that allowed visitors to compose their own mural.

DESIGN FIRM:

Kinetic

CLIENT:
Self-initiated.

PROJECT:
Packaging for refillable detergent dispensers.

Pann Lim, Creative Director, Kinetic:
"This was a project that we did for ourselves. We don't do many self-initiated projects like this; we are quite busy enough clearing day-to-day stuff, so putting aside time to do our own stuff will always be a luxury. It started when I was looking for a decent-looking dishwashing detergent and found that almost all the packaging was mediocre. The bottles I was buying weren't a very inspiring addition to my new home. So I thought of repackaging a detergent by creating a series of refill bottles.

"We thought we could use the product as a gift for our clients as well as in our own homes. Gaining publicity wasn't the intention; we just wanted to do something that we were passionate about.

"As the images on most detergent bottles show only sparkling-clean china, we thought of using 'dirty' images to contrast with this very common imagery. We came up with 15 different images, including oily pasta, greasy hands, a pile of dirty dishes, some squid and ink, dirty underwear, and a chopping board with a bloody pig's brain. We didn't

1

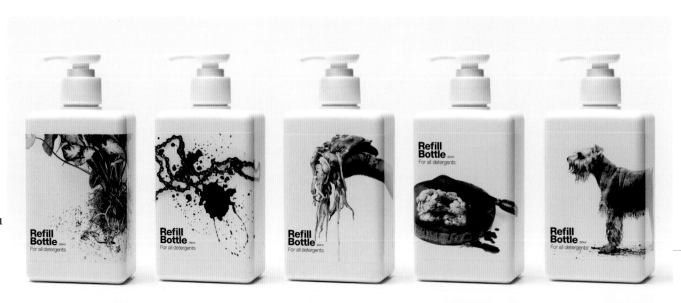

aim the images at specific types of detergent; we just tried to cover as many situations as possible. But, for instance, if you need a bottle for dog shampoo, there's one with a muddy dog on it.

"The only constraint we set ourselves was to try to keep the unit cost down. But doing that while customizing and manufacturing just a small quantity (which accounts for the high production cost of each one) was quite a challenge. After trying out a few prototypes, we decided on one and a mold was made for it. We used an existing proprietary pump. For the images, a lot of props were prepared and we knew exactly the style of photography we wanted. In the end, the results were cohesive and single-minded.

"For us, the project was pure pleasure, from the discussion of what the 'dirty' images should be to the actual photoshoot. It was a 100% expression of our own—not forgetting the input and collaboration of Jeremy Wong, the photographer.

"The underpants got the best response. People always laugh at the underpants, and they always try to find out whether we used real faeces. It was actually a concoction of banana, chocolate, and soy sauce. It smelt okay during the shoot.

"So far no detergent companies have contacted us. I guess it's too alternative; aunties and homemakers would never go for it.

"The bottles are sold online, in design bookshops, and in other design shops. I can't say that they've been successful, but we don't have many left."

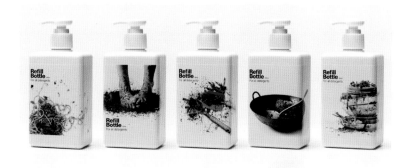

1 Kinetic's detergent refill bottles turn convention on its head and utilize images of dirt and waste instead of pristine dishes and clothes.

DESIGN FIRM:

Milkxhake

CLIENT:
Hong Kong Designers Association.

PROJECT:
Hong Kong Designers Association Awards 2007 campaign.

Javin Mo, Creative Director, Milkxhake:
"The Hong Kong Designers Association (HKDA) was founded in 1972, and the HKDA Awards is a multidisciplinary biannual award for professional designers in the fields of graphic, product, spatial, and new media. It has been a who's-who of design excellence in Hong Kong and Asia Pacific for more than 30 years.

"In 2007, the HKDA celebrated its 35th anniversary. For that year's award, they were looking for something totally different in terms of creativity and approach. They have had a problem attracting young designers and wanted to redefine their role and image through the awards campaign. Most importantly, they wanted to encourage a greater number of talented young designers from the Asia Pacific Region to take part in the awards.

"In the past, the HKDA had used its committee members to take care of different design projects. We are not committee members, and this was the first time they had approached outsiders. Our job was to devise a creative campaign and event identity for three main phases over nine

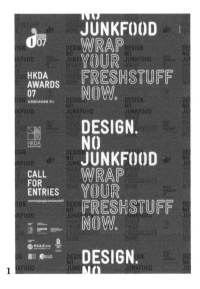

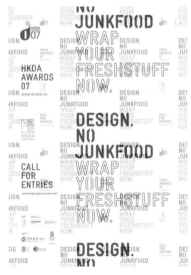

1 The red and white Call For Entries posters doubled as wrapping paper for packaging submissions to the HKDA Awards.

2 Pages from the HKDA Awards website.

3

2

months: the call for entries; the judges' seminars; and the award presentation and exhibition. This included all printed materials and website design. The main constraints were time and budget: we had to clearly define how much the whole process would cost and how to work with different parties in three main phases in the most effective way.

"In terms of creativity, we had absolute freedom in delivering our ideas as we'd been given a clear idea of how far we could go before starting work. When we came up with ideas, we needed to consider whether they could be easily communicated and implemented through all three phases. Most importantly, we really wanted to communicate our thoughts on design through this project.

"We came up with a very simple theme: 'Design. No Junk Food': a provocative statement challenging the value of design in our surroundings. Fortunately, although everyone on the HKDA committee had their own opinion of the statement, they agreed to adopt our conceptual approach.

3 Poster as wrapping paper.

4 Typical wrapped submissions to the awards.

4

5

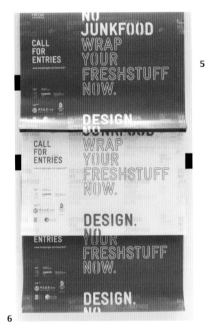

6

"We expressed the theme through massive, bold, red and white 'Call for Entries' posters, which doubled up as wrappers for participants to 'wrap their fresh stuff' as submission entries. We made three wrapper stands as well, which were displayed in the major design bookstores in Hong Kong and allowed people to take the free posters home. This was the most interesting experience: to let the audience define what 'junk food' design meant to them.

"The second phase was the judges' seminar. Six overseas judges were invited to give a seminar mainly targeted at local design students. Our response was to design a set of six stamps, each with a short statement from one of the judges of what 'Design. No Junk Food' meant to them. The students chose their favorite by stamping their invitation card when they arrived.

7

5–6 The posters/
wrappers were available
for free in design
bookstores around
Hong Kong.

7 Stamps featuring
quotes from the overseas
judges were designed for
the judging seminar.

8

"The award presentation and exhibition was the conclusion to the project. The selected entries, wrapped with 'Design. No Junk Food' posters, was the key image, echoing the 'Call for Entries' series. The judges' statements were also used as wall graphics at the exhibition.

"The campaign successfully attracted many young talents in the Asia Pacific Region, especially from mainland cities, and generated a lot of very positive feedback. Most importantly, through the nine-month campaign, a totally new and refreshing image of the HKDA Awards was created among the younger generation of designers."

9

8–9 Poster and website screenshots advertising the judging seminar in July 2007.

DESIGN FIRM:

Number 17

CLIENT:
IAC/InterActiveCorp; US-based group of internet start-ups and acquisitions.

PROJECT:
Very Short List, a website and subscription email recommending one new, classic or overlooked cultural item every day.

1

Bonnie Siegler, Chairman, Number 17:
"The original idea for this came from friends and clients of ours: Michael Jackson (president of programming at IAC/InterActiveCorp and former CEO of USA Network in America and Channel 4 and BBC One in the UK) and Kurt Andersen (author of two bestselling novels, host of Studio 360, and co-founder of *Spy Magazine*).

"We wanted to create something that was like a trusted friend who would cut through the media and entertainment clutter. It took the form of a giftbox that people on a mailing list would receive once a month. It was based on two different thoughts:

1. Grown-ups don't really get presents.
2. There is simply too much media out there to choose from. It's hard to keep on top of it all.

1 Very Short List started life as The Box, a monthly selection of gifts that would give the recipients a "what's hot" guide to new culture.

"The purpose was simply to create a cool new product that we felt filled a void and provided a service at the same time. It was also counterintuitive, which we liked: in this day and age where people want as much choice as possible, we choose for you. And we wanted to make getting the box joyous at the same time. That was it. Our dream was that opening the box would become a moment you would look forward to every month.

2

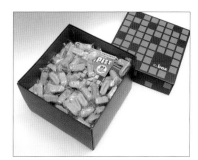

"The four of us started talking about how to develop the idea into a product/service. We were really just winging it and trying to make something we would like to receive.

"We curated the contents, found a food product to include that you could enjoy as you went through the box, designed the physical box and belly bands to go on each item that explained why it was chosen, and a guide to the whole shebang. We also took the time to create little funny extras, like wrapping paper, so you could regift something if one of the items wasn't to your liking. It was a labor of love.

2 The Box 2.0, streamlined after Number 17 received feedback from Barry Diller, chairman and CEO of IAC.

3

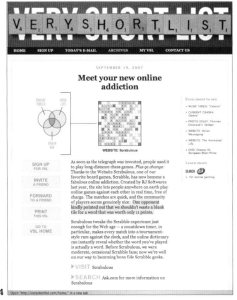

4

"The only constraints came from our own common sense. After we presented the first box to Barry Diller (chairman and CEO of IAC/InterActiveCorp), his comments brought about some changes and adjustments, which, although they made the box less expensive to produce, ultimately made it a better, more streamlined, product.

5

"We made a whole bunch of revisions and presented The Box 2.0 to Barry Diller again. He thought it was much better but wanted us to prove there was an audience out there for something like this. So we went away and invented Very Short List as sort of a virtual, daily version of The Box: you get a daily email with one recommendation (a VERY short list) for an excellent new (or sometimes vintage) piece of entertainment or media that hasn't been hyped to within an inch of its life.

3 Plans for a physical monthly giftbox were eventually scrapped in favor of a daily email with one cultural recommendation.

4 The VSL email of September 19, 2007, recommending www.scrabulous.com, the erstwhile online version of Scrabble.

5 Pages from www.veryshortlist.com.

6

"In terms of design, we wanted the daily recommendation to be the headline and Very Short List to be the messenger. In the header at the top of every email, we put the recommendation both in front of and behind the logo, so VSL becomes a part of the thing we recommend.

"We understand that everything is not for everybody. For our short-attention readers, we added a Venn diagram on the top left of the email that breaks down the essence of the recommendation into three or more familiar things. This way, you can get the idea of the piece at a glance.

7

"In a year and a half, we have grown from a few thousand friends and family subscribers to a list of 100,000. When we write about something with quantifiable results (amazon.com ranking or website page views), the results are spectacular for the item we have recommended. And we love being a part of something that is able to point people to the really good stuff out there, as opposed to the stuff with the giant marketing budgets and fast-food tie-ins. Everyone should sign up! The URL is veryshortlist.com. It's free!"

6 The header of every email weaves the VSL logo into a visual excerpt of the recommendation.

7 To describe each recommendation in terms of other cultural reference points, Number 17 devised a range of mathematical-style formulae and diagrams. The three-circle Venn diagram has since become a feature of every VSL email.

The clients represented in this chapter are varied: a global investment management group, a local theater, a bank, a drug awareness agency, a retro furniture retailer, and a pair of art festivals on opposite sides of the world. But they all have one thing in common: a good fit with their design firm.

In design, as in every other industry, ongoing relationships with clients are vital to business survival. They provide a stream of regular work and income that can see studios through lean times and runs of new business disappointments. What's the secret to making clients stick? Giving them what they need. Every time.

Before you can give them what they need in terms of a service and a solution, you need to know what they need. That requires a two-way conversation. Personalities need to engage so that design studio and client can communicate and a

REPEAT BUSINESS

relationship can start to grow. The right questions need to be asked of the client and the brief in order to develop a thorough understanding of what the real need is.

Often, those questions are best answered by the person at the top. Mario Eskenazi's relationship with the president of Banc Sabadell is of a kind that, nowadays, one only reads about in books about figures such as Paul Rand and the early years of the design profession, before marketing departments made an art of clouding the picture. The image of Eskenazi and the bank president, Josep Oliu, sitting in front of a Mac, "enjoying the possibilities" of the bank's strikingly simple and modern identity, is inspiring.

Equally inspiring are the instances of unlikely match-ups, such as that between hip, laid-back studio Coast and its client Wolubilis Theater, serving a strait-laced suburb of Brussels. By

designing quietly subversive posters that get talked about locally, and nursing the client through the stress of each pre-season period, not to mention winning some all-important praise from the local mayor, Coast has earned the client's trust and loyalty.

But, as all these projects demonstrate, there is nothing like hitting the nail on the head for hitting it off with a client. Number 17 weren't hopeful of a good outcome when they walked into their first meeting with the multi-headed client body of Manhattan's River To River Festival. To their surprise, they won over everybody in the room with their island-spanning identity. "It could have been hell," recalls Bonnie Siegler, "but it was the beginning of a beautiful relationship."

DESIGN FIRM:

Browns Design

CLIENT:
Invesco Perpetual and Invesco Ltd., a UK-based fund manager.

PROJECT:
Brand identity programs and applications.

Nick Jones, Partner, Browns Design:

"For us, the key to winning repeat business is service, service, service: to provide a service as properly and as humanly as possible. You also need to communicate clearly, the ability to go above and beyond, and to give the client the tools they need to win battles on your behalf.

"Invesco Perpetual are the UK's number one fund managers. We won their business with a pitch in answer to a written brief in June 2005. The brief was to create almost every element you would expect in a brand and identity program: logos, stationery, signage, website, and literature, as well as application forms and system-generated customer statements.

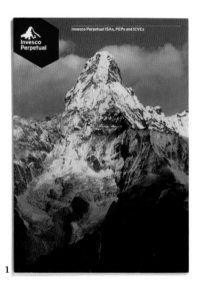

1

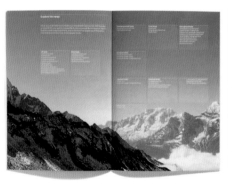

2

1–2 Typical customer literature—an investment guide—redesigned by Browns as part of its review of the Invesco Perpetual brand.

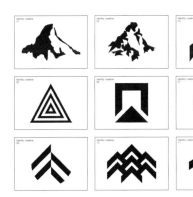

3

"We built a great working relationship with the marketing department at IP, who empowered us to deliver articulate design work not usually associated with this market. The application forms and system-generated documents involved a great deal of time looking at user experience, layout, consistency, and typographic detail, all rigorously working to a grid and type spec then built in a proprietary software package.

"This was largely down to our direct client (the equivalent of a creative director), who was trained in graphic design at Saint Martins [Central Saint Martins College of Art and Design, in London] and who had similar reference points to our own. In addition to the brand work we were also involved in all aspects of design for the Invesco Perpetual Autumn Series of Welsh rugby internationals, which included dressing the Millennium Stadium in Cardiff, Wales.

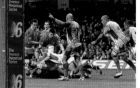

5

3–4 Browns updated Invesco Perpetual's long-standing mountain identity, which went on to be adopted by the global parent brand, Invesco.

5 The Invesco Perpetual program included the promotion of the company's sponsorship of Wales' fall series of rugby

internationals, and involved the design of around 100 items in and outside Cardiff's Millennium Stadium.

"On the strength of that work, we were asked to do another credentials pitch, for the job of overhauling the global parent brand—again, across all areas of communication, but this time dealing with businesses as far apart as the US and Australia and everywhere in between. The global business—then known as AMVESCAP—is one of the world's largest investment managers. They're headquartered in Atlanta, and the company has five major businesses (including Invesco Perpetual) in 47 locations in 20 countries around the world.

6

7

"The head of marketing in the UK was appointed to do the same task at a global level alongside our client from the IP work, the St Martin's grad. A steering group was created to make the key decisions. This was essential so there would be no second-guessing. The decisions were then talked through with heads of business and marketing, who fed in comments and requirements. Working at the global level was more political, with buy-in required at all stages. Previously, we'd got a straight yes or no from the team at IP in Henley.

6 Typical application forms and other literature designed for Invesco Perpetual, illustrating the creative potential of the new symbol.

7 Identity guidelines developed for the parent brand, Invesco.

"The client recognized the need for a clear, accessible, modern, unified, truly global brand. One of the key steps was to adopt the name Invesco as the parent name, and to integrate it into the five distribution brands. The client also wanted a visual 'anchor'—a rallying point for all concerned within the company. The solution was under our noses in the form of Invesco Perpetual's long-established 'mountain' identity.

"This symbol—which, it was decided, should play an integral part in the brand's new identity program—is a contemporary graphic interpretation of the mountain, modeled on Ama Dablam in the Himalayas, due south of Everest. It is often described as the most beautiful mountain in the world. We commissioned Magnum photographer Donovan Wylie and packed him off to Ama Dablam to capture the mountain's true beauty.

"There has been so much repeat business from this. Since then, we've created the identities, visual language, literature system, stationery, electronic communication, and signage for both the US and rest-of-the-world markets."

9

8

8 Magnum photographer Donovan Wylie was commissioned to capture the natural beauty of the Himalayan mountain that inspired the Invesco symbol, Ama Dablam.

9 The format established for Invesco Perpetual investment reports.

DESIGN FIRM:

Coast

CLIENT:
Wolubilis Theater in Brussels, Belgium.

PROJECT:
Posters to advertise events program.

Fred Vanhorenbeke,
Partner and Creative Director, Coast:
"Wolubilis is a cultural village located on the eastern side of Brussels at Woluwe-Saint-Lambert (WSL). It was a dream of WSL's mayor and took more than ten years to build. The theater hosts drama, dance, and music, and started creating its own shows during its second season (2007–8). Besides the theater building, the 'village' is a nice place to spend an evening, with quality restaurants and bookstores that are open late.

"The first project was to create a seasonal events bulletin. The client decided to use us because we used to work for the director of programming, who had been the director of Théâtre de Namur. Coast had grown a good, strong relationship with them over the years. Although we weren't 'imposed' on them, I don't think Wolubilis would otherwise have chosen Coast. They had already commissioned another studio to create a logo, which we didn't feel was right for them, but we managed to cope with it. That's part of the job.

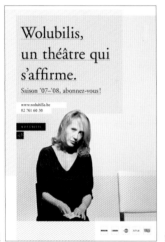

1

2

3

1 Advertising for Wolubilis Theater's 2007–8 season, the second season for which Coast developed advertising, posters, and literature.

2–3 2007–8 season launch advertising, utilizing the "camouflage" system of diagonal gridded lines, designed to put the theater's own mark on standard publicity photography.

4

"There wasn't an instant understanding between us; there hardly ever is. People need to get to know each other to gain the confidence that a client and a graphic designer need. We were all strangers when we first met.

"Clients are often scared of graphic designers indulging the 'artistic' side instead of communication: making work that looks good in a portfolio but that nobody understands. For them, that would lead to shows with no audience. WSL is a rather bourgeois neighborhood for whom graphic design cannot afford to be too avant-garde. That was a clear instruction to us.

"The early meetings took place at Wolubilis. They explained their vision of the new building—eclectic programming aimed mainly at local residents—and what was to appear on the communication items (the logo, the logo, the logo!).

5

4 The "black book" of Coast's Ingrid Arquin, recording part of the development of the overlapping diagonal grid system.

5 Leaflets for Wolubilis productions.

6

"They wanted the logo to provide the basis for the system of designing the bulletin. We didn't see that as a good idea: the logo was not strong enough as a sign. So we managed to convince them to do something else; something based on the building. At the entrance there was a very colorful glass structure nicknamed 'the big one.' Everyone who entered the building noticed it. We noticed it when we first came in. So, at this first meeting, we told them we wanted to create something based on this glass structure, and they agreed. The frames and colors offered lots of possibilities—a certain freedom, but a strong structure, too.

"The first season wasn't a full one; it featured just events. For the second season, we kept the frames and lines (and typography) and developed something a little more detached from the glass structure. We also wanted to leave more white space and let the images stand out more —to push forward the visual world of Wolubilis.

6 Spreads from the seasonal events bulletin for 2007–8, featuring a system of square and rectangular panels for text and photography— an evolution of the system created for the previous season.

"A key factor in how the relationship has developed has been the reaction of the audience. People in the street talk about the posters and flyers, and it has been very positive so far. When the mayor told us he liked what we did, Wolubilis' confidence in us grew. Plus, we know how to work for theaters, so we can give advice on how to communicate, and our client feels secure. We gained experience with Théâtre de Namur and we can now share this with a new client. That's very rewarding.

7

"Sometimes, when a new season is coming up, the client gets stressed. At Coast, we tend not to get stressed. So when a season begins, it's more about taking care of the psychological side of the relationship than the graphical one. But that's only human.

"The reward of designing, for me, is not really about the relationship. Every time a work is concluded and I see it printed, I'm like a kid in a candy store. I'm very, very far from being 12, but still, it's always the same thrill. So that's always a reward. When the client, audience, and fellow Coast designers like the work, that's a reward, too."

7 Posters from the 2007–8 season.

DESIGN FIRM:

Mario Eskenazi

CLIENT:

Grup Banc Sabadell; Spain-based banking group.

PROJECTS:

Corporate and brand identities.

1

2

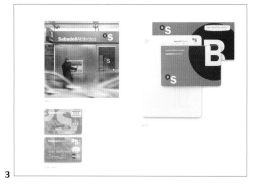

3

4 5

Mario Eskenazi:

"Banc Sabadell was established in Spain in 1881. It followed a natural course of development until 1995, when a younger generation joined its management. Josep Oliu became president in 1996, and appointed a communications advisor, Victoria Quintana. Although the bank had a marketing department, its structures were old-fashioned; the idea was to implement a complete renewal. Victoria knew me from other projects; she recommended me as someone who could help the bank with a new challenge: to expand in Spain from the seed of a new bank, Solbank.

"My first meeting with the president was at the presentation of Solbank's corporate identity. There were four people there: Josep, Victoria, the deputy director, and me. They were very enthusiastic, right away, about the one solution I presented: they found it very logical and natural. Perhaps that's what made the meeting very relaxed, like a group of friends solving a problem together. At that point we had a language in common: the concepts.

1 The stark, simple identity system for Banc Sabadell and its four other brands presented a huge shift from the tradition of Spanish banks.

2 Logos for enterprises and events sponsored by Banc Sabadell, illustrating the flexibility of the basic identity.

3 Applications of the Sabadell Atlántico identity.

4 Letterheads of three of the group's banks.

5 Poster for the Open 2008 Sabadell Atlántico tennis tournament in Barcelona.

"I had almost total freedom. Solbank was established when Banc Sabadell took over NatWest in Spain in 1996, to initiate its nationwide expansion. The only requirement was to maintain something in common with NatWest's corporate identity. I kept the sans serif typography (Franklin instead of Helvetica), and a similar color. NatWest used Pantone 201, a dark red, and I changed it to a brighter shade, Rhodamine Red. This is less ubiquitous than Pantone 485, which is used in more than 70% of the world's logotypes. These were logical requirements that did not influence the design. With that name (Solbank, that is, 'Sun' Bank), the use of a brighter red was logical. And in the idea of the circle with the 'S' there was no place for serif typefaces.

"I think that the success of this identity was partly due to its notoriety as much as to the use of colors and the simplicity of the symbol. Until that time, the identities of Spanish banks had been quite baroque, trying to represent wealth rather than functionality.

"While I was developing Solbank's identity, the clients came to me with a concern. Could it converge with that of Banc Sabadell? And if, in the future, Banc

6–7 Banc Sabadell's 2006 annual report and accounts, featuring the new identity.

Sabadell became a group of bank brands, would it be possible, from the starting point of Solbank's identity, to create a flexible system that would allow for the development of a Banc Sabadell Group identity, incorporating new banks and new names?

"When I saw the possibility of creating a coherent system, we met at my studio. It was my second meeting with the president, and he arrived with his communications advisor late on a Tuesday afternoon. We spent a couple of hours in front of my Mac, enjoying the possibilities of the new graphic code for the bank (changes in colors and capital letters). Graphically, we found a way to absorb any bank and make it fit into the Banc Sabadell style. That was the beginning of what I now think of as a personal relationship.

"For each bank, the symbol is made from the capital letter of the name of the Bank (Solbank: S, Sabadell: S, Asturias: A, and so on) in black, and to its left, a colored circle (the color depending on each bank), with a letter 'B' in white inside it. For Banc Sabadell, the 'S' is black and the circle is blue (the old identity of this bank was blue—another blue). For Solbank the circle is Rhodamine Red, and for Banco Asturias the circle is blue (as in Sabadell).

8–9 Identity guidelines showing the naming system and the use of color in applications.

10 Banc Sabadell logotype.

11

12

13

"In 2006, with the acquisition of Banco Atlántico, the Group became Grup Banc Sabadell. The name of Banc Sabadell changed to Banc Sabadell Atlántico, and 'Banc Sabadell' is now the name of the Group.

"The system had to be updated to meet new requirements. It was decided to keep the blue circle with the 'S' as the symbol for the Group, and each Bank has the circle and the 'S', in black. The name 'Banc Sabadell' is in a small size over the name of each bank, and a large circle with the color of each bank is added in a corner of each printed item.

"I think the identity was ground-breaking for several reasons. Up until then, the identities of banks were monolithic, based on an untouchable, generally abstract symbol. They also were, and still are, purely decorative. The surprise was, first of all, the colors—very daring for a bank—then the clarity and simplicity, and finally the extreme flexibility: various banks with different names, all referring back to the same system. Every new bank fits into the graphic system seamlessly.

"What allowed me to develop this project so successfully was the absolute freedom and trust awarded me by Josep Oliu, and the fact that I could talk things through with him directly, with no intermediaries."

11 More identity guidelines.

12 The creation of the Solbank ("Sun" bank) identity preceded that of the Banc Sabadell group.

13 Logotypes developed for each constituent bank in the group, in which the bank is identified by the color of the circle and the first letter of its name.

DESIGN FIRM:

Inkahoots

CLIENT:
Needle and Syringe Program
division of Queensland Health.

PROJECT:
Drug education campaigns.

Jason Grant, Designer and Director, Inkahoots:
"The Needle and Syringe Program division of
Queensland Health implements Australian
government policy to reduce the harms associated
with injecting drug use, particularly the transmission
of blood-borne viral infections such as HIV/AIDS and
hepatitis B and C. They provide sterile injecting
equipment, education and information, treatment
referrals, and medical, legal, and social services. We
met through one of their workers, who was a poet in
a poetry festival for which we had done the design—
always a great way to meet a government client.

"Our first project for the program was the creation of
an icon symbolizing needle recycling for application
at chemists, medical facilities, and sharps disposal
bins. It needed to be pretty literal, but couldn't
appear too 'sharp' and unfriendly. It was a small
triumph making a needle not look threatening.

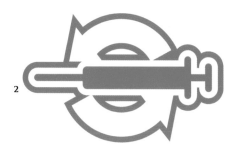

1 The illustrations
represented emotional
and psychological themes
of publications and
information cards from
Queensland's Needle and
Syringe Program.

2 Inkahoots' first
assignment for QNSP: an
icon to indicate the
availability of needle
recycling facilities.

"The Amphetamine Awareness campaign was initiated mainly to inform health workers about the nature of amphetamines, the people who use them, and why they are used. We designed several publications including a Briefing Paper workbook, Recovery Guide, Brief Intervention information cards, and posters, T-shirts, and murals.

"After cannabis, amphetamines are the most extensively used illicit drug in Australia. There is no typical user, although usage is highest among young, white males. Its reputation as a party drug is countered by its usage among truck drivers and shift workers.

"Because the audience for the campaign was both health workers and drug users, it needed a sensitive balance between a visual language that wasn't typically bureaucratic and one that wasn't flippant or condescending.

"We developed a range of illustrations that symbolize or evoke the publications' themes. Psychological and emotional sensibilities are represented through abstract images: patterns of blurred lines accompany 'Types of Speed'; an abstracted lion is used for 'Strength and Toxicity'; a colorful moiré pattern for 'Sleep.'

3

"It took a lot of playful visual experimentation to find the right tone. The difficulty was aiming at certain themes without solely trying to capture subjective drug experiences. We wanted a bit of this, but also needed to avoid gratuitousness and any suggestion of 'positive promotion.' This was aided by a restricted color palette and restrained, straightforward typography.

"The next project was a book about steroid use. As with all this work, it was a great opportunity to find an engaging visual medium for potentially clinical subjects. For *The Steroid Book* we designed and fabricated relief metal plates that were then photographed to suggest the drug's culture of exaggerated masculinity.

3 QNSP materials have avoided direct visual references to drugs, as this briefing paper on amphetamine use demonstrates.

"Typically, government processes for consultation and approval can result in conservative, inappropriate outcomes. The people we're working with on these projects very successfully guide and defend design through this process. They trust our approach and in turn we can rely on them to provide feedback that relates to the real communication goals of the project.

"Because the client generally wants to avoid obvious visual references to drugs, the design always needs to find other ways of relating to and expressing the subject. This challenge usually leads to unexpected but convincing results."

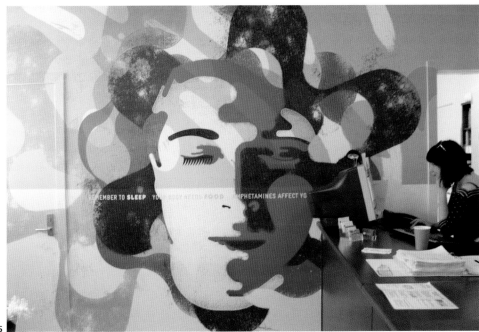

4 Information poster providing advice on coping with amphetamine use.

5 Mural by Inkahoots at the QNSP's Brisbane offices.

DESIGN FIRM:
Kinetic

CLIENT:
Lorgan's The Retro Store;
Singapore-based furniture retailer.

PROJECT:
Website and campaign posters.

Carolyn Teo, Managing Director, Kinetic:
"Lorgan's is a vintage furniture shop that carries
timeless retro classics from the 1930s to the 1970s.
It's the largest vintage furniture retailer in Singapore.

"We first met Lorgan's when Sean Lam and Benjy
Choo were working on a website for them
(www.lorgans.com). Most of us are avid collectors of
retro furniture, so we have a passion and love for
vintage culture, be it a chair, table, table fan, pendant
lamp, stool, or even stationery containers.

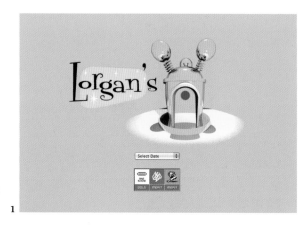

1

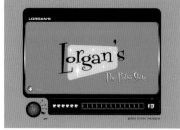

2

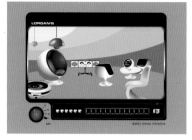

1 Kinetic has designed
for Lorgan's since 2001,
when it created the
retailer's retro-flavored
website.

2–3 Pages from the
Lorgan's website.

3

"The website was designed back in 2001. Lorgan (Wong, the shop's founder) provided us with a brief, we presented the concept, he approved it straight away, and we never looked back. We decided to use a time-travel theme that allows people to travel back into the retro period of their choice. We split the site and furniture into 1930s–1950s and 1950s–1970s; each of these two time zones had a distinctive mood, and this reflected on the difference in style of the furniture sold. What we created was a fun 'walk back in time' that allows a person to be engaged in the era, and browse the furniture sold.

"This has been a simple creative relationship where we both respect each other for the work we do. Lorgan provides us with leeway in terms of what he expects to see and, as long as we deliver the brief in a style and message we're proud of, the project usually takes off smoothly. Over the years, of course, there is less need to clarify matters with the client, as you become an extension of the brand, rather than the agency.

4

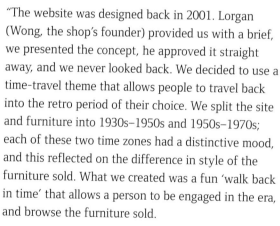

4 Lorgan's A–Z of modern furniture, featuring silhouettes of classic pieces from its collection.

"Winning our first few awards was the cement that sealed the relationship. The site won several international and local awards, which led to a sudden surge of visitors to the site, and it was published in several design publications and books. The client is appreciative that, thanks to design, a relatively 'small' brand such as his has created international ripples. The relationship has now lasted more than seven years. With each year that goes by, we have taken new approaches to 'advertising' his business, with some hits and misses along the years.

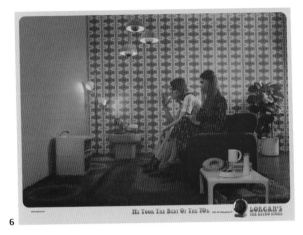

6

5

Pann Lim, Creative Director, Kinetic:
"The 'We Took The Best of The 50s/60s/70s' series of posters came about because we wanted to showcase an iconic piece from each particular period. For the 1950s, we thought it would be funny to see a typical American family sitting on the floor having dinner because we have taken their Eero Saarinen chairs away. For the 1960s, it's the Nesso lamp, and we have a granny reading in the dark. And for the JVC Videosphere TV, we thought it would be interesting to show a couple watching a blank wall.

5–6 Ads from the 'We Took The Best of the 50s/60s/70s' campaign.

7

"The 'Irrationally Desirable' campaign actually focuses on buying items from Lorgan's not because it complements an interior, but because the owner wants the object so badly.

"The Sale/Bazaar/Offer posters were used to advertise a sale event in 2006. The challenge with Lorgan's is always to keep the cost down. Instead of a photoshoot, Roy Poh (ex-Creative Director) thought of using typography for the project because it's both fast and low-cost and, on top of that, it's conceptually strong. We had just two or three days for the project and everything was done in-house. We are all very hands-on guys."

8

7 Posters from the 'Irrationally Desirable' campaign.

8 Posters for a Lorgan's sale event in 2006.

DESIGN FIRM:

Milkxhake

CLIENT:
Microwave; Hong Kong-based media arts organization.

PROJECT:
Identity and campaigns for the Microwave International New Media Arts Festival.

2

3

1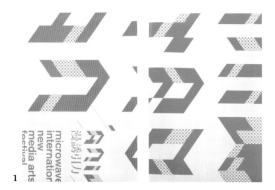

Javin Mo, Creative Director, Milkxhake:
"We first worked with Microwave in 2006, when they asked us to design a new identity, followed by all of the printed graphics, promotional items, and a website for the 2006 Microwave International New Media Arts Festival, all within a very short space of time—just two months. Microwave showcases cutting-edge new media arts from different parts of the world, and their annual festival has run for over ten years.

"Before we designed anything, we had quite a few meetings with the client and shared our thoughts on their existing identity. As they were a totally new team, they were quite open-minded and looking for something totally refreshing, and we discussed how far we should go beyond the existing identity. We also made an in-depth study of different Hong Kong arts organizations' identities: none of them had placed much importance on their identity or on promotional printed matters such as flyers and brochures. That helped us to clearly define the project's objective: to establish Microwave as the most important new media arts organization in Hong Kong, bringing the latest developments in the fusion of technology and art; and to position it internationally as a new media arts icon.

1 Microwave 2006 stationery, elements of a full identity program developed by Milkxhake in just two months.

2 Microwave 2006 logo.

3 Posters for Microwave 2006.

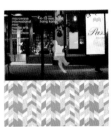

4

5

"The next step was to devise the identity. We created a new form of 'evolving' identity, inspired by the basic form of a wave, or 'm.' This projects stability but it also embodies a strong element of flexibility and motion when multiple Microwave logos are seen together.

"The new fluorescent brand colors signal a strong relationship with new media and light, and generate the idea of an evolving identity. All promotional items and the website for the 2006 festival were based on moving typography that mixed fluorescent orange and green. Other fluorescent colors would be used as the theme colors for each festival in the following years.

6

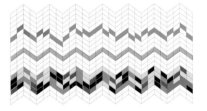

4 Spreads from the brochure for Microwave 2006.

5 Animatronica logotype for Microwave 2006.

6 Microwave 2006 logo evolutions and their typographic development, with the "m" taken from an angular, gridded waveform.

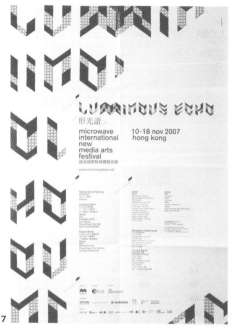

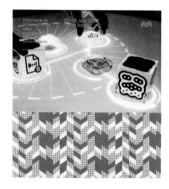

7

8

9

"The new identity helped the 2006 festival to attract the largest number of visitors to the show since 1996, and for us it cemented a very good relationship with Microwave. The identity attracted lots of attention in the local arts community and, in 2007, Microwave commissioned us to do a repeat for the 2007 festival. We chose shocking fluorescent pink as the main theme color. We also went on to become working partners for larger-scale projects.

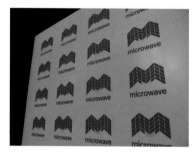

10

7–10 Poster, brochure, packaging, and projections created for the shocking pink Microwave 2007.

11

"In April 2008, Microwave organized the 'A-Glow-Glow' Macro Interactive Media Arts Exhibitions, featuring United Visual Artists (UVA) from the UK, with their award-winning *Volume*, and the spectacular world premiere of *Phaeodaria* by Hong Kong-based LED artist Teddy Lo. Both of these were exhibited in the famous Avenue of Stars by the waterfront in Tsim Sha Tsui, echoing the grand city lights that color Hong Kong's night skies.

"Again, we were commissioned to design the whole event identity, from printed materials and website to limited-edition products for the exhibition. The 'A-Glow-Glow' logotype was inspired by a 'neon light' typeface with an open and closed outline, depicting the 'glowing' effect. Vibrant cyan and purple were chosen as the main event identity colors, echoing the 'luminous' concept for the installation artworks.

"The exhibitions have successfully attracted more than 100,000 visits by both local people and tourists, and transformed the perception of people here toward new media arts in public spaces."

12

13

11 Pages from the Microwave 2007 website.

12 Poster for Microwave 2008, the third festival designed by Milkxhake.

13 Microwave 2008 exhibition.

DESIGN FIRM:

Number 17

CLIENT:
Organizers of the River To River
Festival; arts festival in downtown
Manhattan.

PROJECT:
Identity, applications, and
event publicity.

2

3

1

Bonnie Siegler, Chairman, Number 17:
"We started working on the River To River Festival in 2003, when it was
one year old. The festival was created the summer after September 11, to
bring people back downtown. Today, it's a music, art, dance, and
performance festival with more than 500 events in venues all over
downtown Manhattan. It is mostly for people who live and/or work in
and around New York City, who may not think of traveling back into the
city or going to downtown Manhattan for an event on a weeknight or
weekend. And it's free!

"Our first project was to come up with a festival identity. Our first
presentation was in a giant conference room. We were on one side of a
very long table and 15 people were on the other side. There were River
To River people, representatives of each of the seven presenting partners
(including The Port Authority of New York & New Jersey, South Street
Seaport, and the Lower Manhattan Cultural Council), and representatives
from a few of the sponsors.

1 Poster for the second
River To River Festival in
2003, the first one to
involve Number 17.

2 Program cover
from 2003.

3 Banners from the
2003 festival.

"It was very intimidating and could have gone really badly, with half the room going one way, and half going the other, and us going back to the drawing board. But it didn't. There was a great initial response and, crazily, almost unanimously, they all gravitated to the same idea. It could have been hell, but it truly was the beginning of a beautiful relationship.

"Each year since 2003 we've created around 65 print ads, a new or updated/revised website, a program guide, three designs for streetlight banners, six different stage designs, five banners to be hung at venues, and 12 posters, along with miscellaneous items such as tickets, T-shirts, and e-blasts. The events are wide-ranging and plentiful and we really do try to appeal to all audiences.

"The first two years each had fairly different creative directions from each other. That was great because it gave us the opportunity to redesign our own thing year after year. Then we created an identity that we have evolved over the last four years.

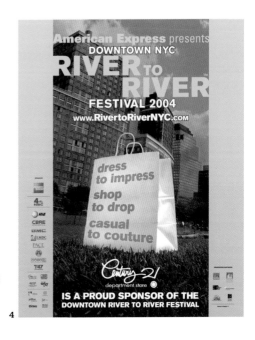

4

5

6

7

4–7 Poster, banners, trifold leaflets, and program from the 2004 festival.

"For the 2005 campaign, we came up with the idea of the city grid, and used greens (to symbolize the parks and grass) and grays (to symbolize the cement and streets) to create an abstract representation of our city, where all the events are held.

"That system worked really well in communicating the wide range of events and information we had to convey, so we kept it in 2006. We decided to add in photography of grass to update the look and to add a little depth. We also introduced some hot accent colors that were used to pop out festival messages.

"For the 2007 campaign, we replaced the grass images with images of the sky and clouds, which added even more depth, as our palette expanded to greens, grays, and blues.

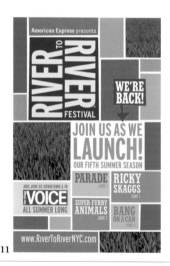

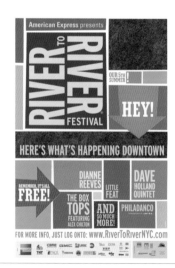

8 In 2005, the current identity was designed, and a "city grid" format developed for publicity. This poster was one of the first manifestations.

9 Leaflets and banners for the 2005 festival.

10 Leaflets from 2006, featuring photography of grass.

11 2006 festival launch poster and subway poster.

"In 2008, we wanted to add more depth so we picked up on the city grid idea, and used pop-up boxes to create a greater hierarchy across all the pieces. We also used the accent colors more liberally, which brought a more youthful quality to the campaign.

"Evolving the identity has been rewarding because it has given the city time to really get to know it and recognize it. It's been fun to see how one concept can be reinvented and reinvigorated over and over.

"We learn what works and what doesn't from year to year. So we definitely know what we are doing. Also, it's pretty easy to gear back up for River To River after so many years. We know what to expect and who we're working with, so things fall back into place pretty seamlessly. We have a great relationship with the client, so there is a comfortable shorthand built in to every meeting, even when we are presenting new creative work. We have the benefit of being like an in-house design department while being out-of-house. And being able to see some really great concerts and events is a nice reward, too."

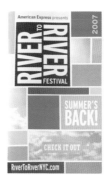
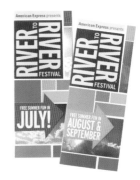

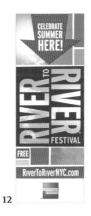
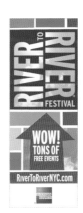
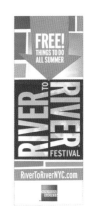

12

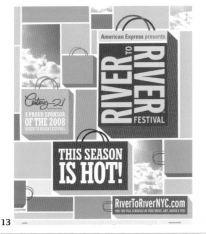

13 **14** **15**

12 Program, leaflets, and banners for the 2007 festival, with clouds taking the place of grass.

13 2008 festival poster featuring shopping bags produced for retailer sponsor Century 21.

14 General publicity in 2008 such as these banners used more three-dimensional boxes to highlight the main information.

15 The Rockefeller Park stage at one of the events in 2008.

"Ideas are cheap," said Charles Eames. "Always be passionate about ideas and communicating those ideas and discoveries to others in the things you make."

Eames, from his days of gluing together pilfered sheets of plywood in his small Westwood, LA, apartment, knew a thing or two about designing on a shoestring budget. His unpaid experiments in molding ply would stir up a revolution in affordable furniture design. It is the classic dirt-cheap design case study. Idea plus passion equals solution. The projects in this chapter include inspirational ideas, passionately delivered at low cost.

Mario Eskenazi's stenciled red-ribbon identity for the AIDS charity Fundació Sida i Societat is a masterpiece of economy and practicality. Kinetic's packaging for The Observatory's *Time Of Rebirth* CD seems lavish and handmade but cost next-to-nothing. The band's frontman provided diary-esque jottings, the rest of the group (and studio) was roped in to tear out pages from the journals, and the torn-out paper was sold to a recycling plant.

Low Budget

How Coast, in Brussels, managed to get 11,000 bags, 10,000 event programs, 15,000 flyers, 5,000 invitations, 10,000 badges and a sign system made on a budget of €20,000, all for a three-day fashion festival, defies belief. But, for the studio, it was a cause they believed in, one that would challenge their resourcefulness to the limit—and one that would win them a healthy amount of press coverage.

Inkahoots, in Brisbane, convey their commitment to social causes through every piece of design and artwork they create, and they rarely have much of a budget to play with. *The Admissions* interactive public artwork was no exception. The group wanted to confront the absence in public spaces of opportunities to make choices about the big issues, rather than the ones we're used to, such as which brand of coffee to buy. It was a painstaking process, and one that Inkahoots had to subsidize themselves.

Browns' exhibition catalogs for illustrator Paul Davis and Number 17's annual Christmas gifts have been completely self-subsidized. Paul Davis'

sketches and scribbled musings seem ideally suited to a modest monochrome treatment, although, as Nick Jones reports, Browns have also showcased his work in the most lavish of books. Number 17 evidently love the challenge of coming up with and producing a Christmas gift at the last minute. Despite the stress and expense, they have done it (almost) every year since 1993.

Low-budget jobs can make designers find new ways of delivering their ideas. They can, as Bonnie Siegler says, be very satisfying. But you probably shouldn't make a habit of them.

DESIGN FIRM:

Browns Design

CLIENT:
Paul Davis; British artist.

PROJECT:
Exhibition catalogs: *Lovely; What Do Californians Think of England/ the English?; It's Not About You; God Knows.*

1

Nick Jones, Partner, Browns Design:
"We've have had a close relationship with Paul for many years, working on various projects and pitches. There were two exhibitions of Paul's work at the Browns Gallery and one each at The Wapping Project, London, and Colette, Paris. These publications were produced as exhibition catalogs for those four shows. They were done as favors-in-kind in return for the generosity Paul had shown in helping us out. It has been a reciprocal arrangement. He does a bit for us; we do a bit for him. Print for these publications was kindly provided by Westerham Press and The Good News Press.

"All of the catalogs were 8 to 12 pages long, printed predominantly in a single color, collated A3 or A4 [11¾ × 16½ or 8¼ × 11¾in] and folded newspaper-style to minimize production costs. They sat perfectly with the shows. *God Knows* was acknowledged by D&AD for both design and illustration. The 'What Do Californians Think of England/the English?' exhibition later evolved into the bestselling *Us & Them*."

2

1–2 Spreads from "God Knows."

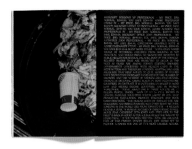

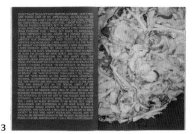
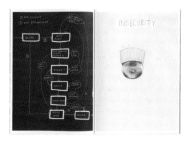

3

4

"Paul's work looks quite instant and immediate, but I think it's wrong to assume that the low-budget presentation is the right medium for his work. Paul's work can be quite colorful. In some ways, the black and white nature of the catalogs was purposefully passive as a contrast to the vibrancy of his work in the flesh. It makes the viewer focus on the content of the drawings as opposed to the paper it was drawn on or the color used.

"We also self-published his book *Blame Everyone Else*, which had 12 paper stocks, five units, foiling, and a selection of posters that doubled as dust jackets. Jon (Ellery) describes it as the most ambitious book he has done. It was one of the first books to print on the uncoated side of mirrored Chromalux and featured contributors such as Ryuichi Sakamoto.

"With more of a budget, we might have used more paper stocks and maybe more print techniques. We would also have thought more about delivery and packaging."

3 Spreads from "God Knows."

4 Cover and spread from "Lovely."

DESIGN FIRM:

Coast

CLIENT:

Modo Bruxellae; organization promoting the fashion industry in Brussels.

PROJECT:

Identity and applications for Modo Bruxellae 2004 festival.

Fred Vanhorenbeke, Partner and Creative Director, Coast:

"We say yes to jobs with a small budget if:

1. We believe that the job offers an opportunity to create something new in design terms.
2. It is likely to get us some good press.
3. It is likely to bring to us new jobs in that field.
4. It's for friends.
5. It might lead to other jobs for the same client.

"When we were starting out, we did a lot of low-budget jobs. It is an absolute necessity for a young graphic design practice to work for a small budget, even for free. Strangely, the less money people have, the more creative they are.

1 Flyer for Modo Bruxellae 2004, the tenth time the Brussels fashion weekend had been held.

2 With a small budget, color and conventional materials were out of the question. This program was printed on newspaper stock.

3 Invitation.

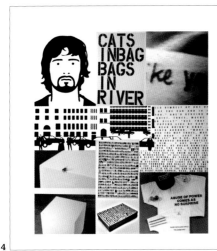

4

5

"Modo Bruxellae is an association promoting the city's fashion designers and labels. Every two years it organizes a designer weekend: a festival devoted to fashion with exhibitions, workshops, late-night shopping, and parties.

"When we designed Modo Bruxellae 2004—its tenth anniversary—there was a budget of €20,000 [US$25,000], which had to cover the design and production of 10,000 event programs, 10,000 bags, 15,000 flyers, 5,000 invitations, 1,000 limited-edition bags, 10,000 badges, and a custom-made signage system. All for a three-day event!

"We said yes because Modo is a real Brussels institution. Designing for Modo gets your work seen all over Brussels and on the media.

6

4 Boards produced during the development of the Modo identity, showing inspirations and draft designs for shop stickers.

5 The final Modo logotype.

6 Rejected logos.

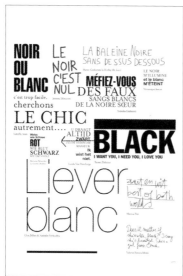

7

8

"We also wanted to do it because fashion is a topic we're really passionate about. Modo features known designers and new talent; students can display their work; and there's an award that helps young designers to create their first collection.

"Another big factor was that the artistic supervisor for Modo 2004 was Didier Vervaeren, a very talented fashion designer and a very nice human being. The collaboration was challenging because Didier only goes for the best; he is very demanding and has a real eye for quality. On the other hand, he understands artistic freedom, even with graphic designers. He listens a lot and understands communication. There was a real exchange. It was one of the best working collaborations we've ever had with a client.

7–8 Pages and cover from the Modo program.

9 VIP bags for the festival were created using fabric off-cuts from designers' workshops and factories.

10 The standard black and white Modo bag, still able to catch the eye on a Brussels street.

 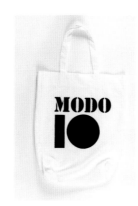

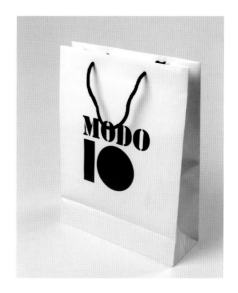

9

"Because there was no budget, we decided to create everything in black and white (even Didier chose the theme according to the budget: black and white) and play with elements other than color: typography, a newspaper-like program, signage stickers, and black and white bags.

"Modo is an institution but is also very 'arty,' although not in a serious way. So for the signage stickers we created large white stickers and asked participants to sign their name on it, so all the stickers were different in the end. For the VIP bags, we created around ten different bags in different fabrics and just screenprinted 'Modo' on them.

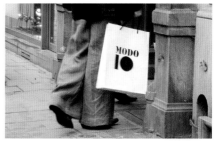

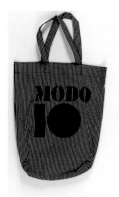

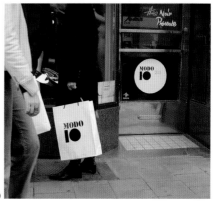

10

11

12

"We had to create a signage system to show all the different places people could visit during the weekend. Each place had a number. To cut costs, we asked students to stencil all the numbers on a vinyl circle previously stuck on windows.

"The lack of budget made us think in a different way and find new solutions. You can also go deeper in your work. You have to explore every possibility and that's very exciting. It's like a game; the rules were 'no budget' and 'black and white.' And then you start playing.

11 Design for the signage sticker, indicating shops participating in the fashion weekend.

12 Students stenciled numbers onto the stickers to tie in with the festival participants' numbering system.

"The solution was very appropriate to Modo: no fuss, very rough, real. It says 'here's what we are.' I don't know if we would have done it differently if the budget had been bigger… The answer is probably yes.

"The project created some strong links between us and people we still work with. Low-budget jobs tend to bring people together, and most of the time it's a rich experience."

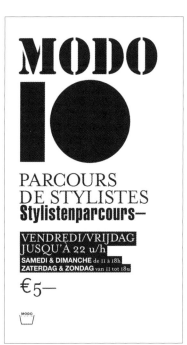

13

13 Posters produced for the event.

DESIGN FIRM:

Mario Eskenazi

CLIENT:
Fundació Sida i Societat (SiS);
Spain-based foundation working
on AIDS prevention.

PROJECT:
Corporate identity and
applications.

Mario Eskenazi:

"For me, the size of a client's budget is completely irrelevant; it has no impact at all on the creative process. I don't often work on projects with an extremely small budget; it just doesn't seem to happen.

"Sida i Societat's mission is to contribute to the prevention and control of AIDS and other STDs in developing countries. It emphasizes the need to work on structural contexts such as poverty, lack of education, and violence. It's a private foundation based in Barcelona, financed through its own funds, private donations, and institutional contributions.

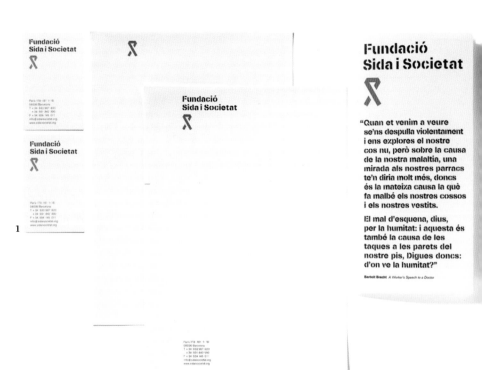

1 Stationery featuring
Sida i Societat's stenciled
red ribbon identity.

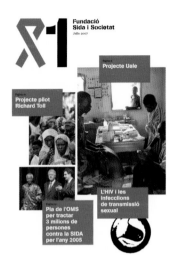

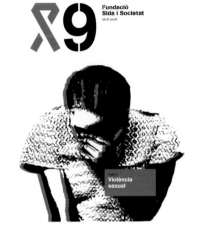

2

"I got involved with SiS because their marketing director had been working at Médecins Sans Frontières [Doctors Without Borders] and knew my partner on this project, Diego Feijóo, from there (Diego has been working with MSF for ten years). SiS emerged out of the Fundació Barcelona SIDA 2002, on the occasion of the AIDS International Congress in Barcelona in 2002, and needed an identity to establish them as an independent organization. Their brief was very simple: they needed to be identified as a foundation that worked against AIDS. The budget was minimal as the foundation had limited resources, and it had to cover the identity, symbol, typography, website (www.sidaisocietat.org), stationery, T-shirts, and newsletter. But we managed to keep it all within budget. I don't know what the budget would be for an equivalent project in the case of an international charity."

3

2 Magazine covers. **3** Pages from www.sidaisocietat.org.

4

5

6

"The size of the budget has no impact on the design or the creative process itself. However, what we did take into account as a fundamental aspect of the project was the fact that the organization would have extremely limited funds for the implementation. We realized that whatever we did would need to be applied to the walls of the foundation's clinics in Guatemala and Senegal. The cheapest form of signage we could imagine was painting directly on the walls. That led us to an identity based on stencils.

**Fundació
Sida i Societat**

ABCDEFGHIJKLMNOPQRS
TUVWXYZabcdefghijklmno
pqrstuvwzyz1234567890&@
ＸＸＸＸＸＸＸＸＸＸＸＸＸＸＸＸＸＸＸ

7

4–6 Creation of the SiS logo, easily and affordably applied to the walls of clinics in the field.

7 Typographic alphabet.

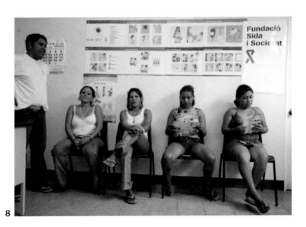

"As the red ribbon is a universally used sign for the fight against AIDS, we combined those two things and created a stenciled ribbon as the foundation's symbol."

**Fundació
Sida
i Societat**

**Fundació
Sida i Societat**

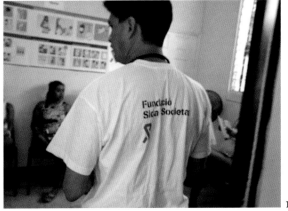

8

9

10

8 Typical SiS clinic in Guatemala.

9 On T-shirts and other items, the logo makes a highly visible, powerful statement.

10 Alternative configurations of the logotype.

DESIGN FIRM:

Inkahoots

CLIENT:
The Museum of Brisbane.

PROJECT:
Interactive public artwork curated by the Museum of Brisbane.

Jason Grant, Designer and Director, Inkahoots:
"Creativity doesn't have anything to do with money. When a project comes along, budget is just one of the factors to be considered. It's important, but not as important as the nature of the client and the brief's creative scope. The reality is, though, that we can only do so many subsidized projects before it's a problem for the financial sustainability of the studio.

1 2

"We were originally approached by the artistic director of Queensland's major arts festival to create something for their program. It then became part of a temporary public art event curated by the Museum of Brisbane, designed for city 'laneways, pocket parks, and concrete nooks.'

1–4 Admissions was a public artwork in Brisbane that invited pedestrians to register their support for issues by walking beneath projected animations of words and phrases— and was created on a shoestring budget.

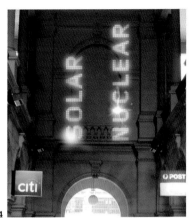

3

4

"The original brief was, 'Make something anarchic!' Who's going to give you lots of money to make something anarchic? The total budget was AUD$27,380 [US$23,000]. That was for all the design, animation, programming, research, production, equipment purchase and hire, troubleshooting, and maintenance—months and months of work. I'd rather not think about what it actually cost.

"We wanted to make an interactive, collectively generated artwork as a public challenge to our common spaces. We wanted to ask, why is it that messages about the issues most relevant to our lives are quarantined away from public spaces, while we're relentlessly assailed with trivial choices about what to buy?

5

6

5–6 Twenty-one separate typographic animations were produced. Words swelled or shrivelled in size according to the degree of support they were receiving at the time.

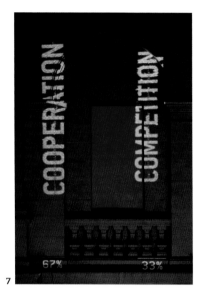
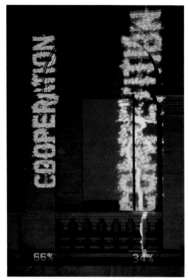
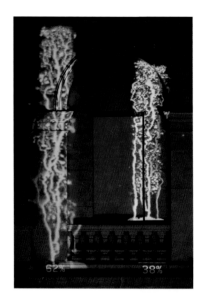

7

"The work offers a choice between two halves of a provocative binary, displayed on LED panels suspended over the city's General Post Office laneway. As a pedestrian passes under one it triggers a sensor, and the data feeds a video artwork projected onto the lane's archway. Different options were displayed every day. The statements consist of animated typography constantly changing in size relative to the ratio of 'votes' they receive as people pass under the panels, resulting in an animated, visual duel between two ideas.

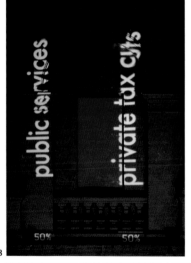

8

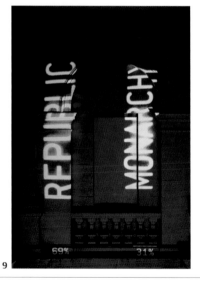

9

7–9 Half of the animations were design-intensive, involving custom-made typography; the other half, to keep costs down, had to remain modest.

"We had originally intended to create a new typographic animation for every day of the festival. As it ran for six weeks this would have meant 42 unique animations. To cut production time we made 21 and then repeated them so they appeared twice during the program. It worked well in the end because it gave people a chance to familiarize themselves with the work and vote for an issue they'd missed. To reduce production time even further we designated half the 21 animations as 'basic' (simple, easily created), and the other half as 'design-intensive' (more complicated, experimental, and ambitious).

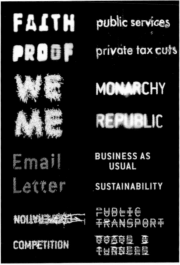

"We created the animations by inventing video and stop-motion experiments. For 'solar/nuclear' we built letterforms out of tea candles and sprayed them with kerosene to create bursts of flame. For the 'proof/faith' letterforms we set up flower buds and regularly photographed them as they opened and then died. For 'public services/ private tax cuts' we filmed the typography through moving water in a fish tank.

"There were between 10,000 and 20,000 people encountering the work every day, so we got mixed reactions. Some people didn't even notice it; some refused to acknowledge it; some loved it; some resented being induced to make a public choice; some were offended; some were excited. We just can't wait to do it again somewhere else."

10 Filming the animation for "public services/ private tax cuts" through water in a fish tank.

11 A selection of the more experimental combinations.

12 Sketchbook with initial ideas for the provocative oppositions.

DESIGN FIRM:

Kinetic

CLIENT:
The Observatory; Singapore-based rock band.

PROJECT:
Time Of Rebirth CD packaging.

1

Pann Lim, Creative Director, Kinetic:

"To me, creativity is not necessarily bounded by budget. It is true that with a bigger budget we can achieve more in execution. However, the idea is still king. With high budgets and low ideas, the work will still turn out bad. I still prefer low-budget projects with nice ideas.

"The Observatory is an indie space rock and electronica band based in Singapore. Some of the guys in Kinetic play in a band too, so when The Observatory were planning to release their album they approached us. We have known them for many years, so the relationship was tight. The band were very helpful in providing information we needed.

"I think the budget was under SGD$3500 [about US$2,500], including printing. As Singapore does not have a very big market for 'local' music, budgets are always small. We don't sell millions of records.

"The brief was to design a CD that would reflect the title, *Time of Rebirth*. The Observatory was formed by members from several different bands, and *Time of Rebirth* is like all the band members coming together and starting a new chapter in their music careers.

2

1–2 Low-budget packaging for The Observatory's "Time of Rebirth" CD took the form of a diary printed on cheap stock, with torn pages, scribbles, and notes.

"We designed the cover to look like front man and songwriter Leslie Low's diary. Inside the diary, we tore away the front pages (to represent a tearing away of the past), leaving behind the new chapters, which signify the new birth of the band. To make the project as authentic as possible, the scribbles were written by Leslie himself, while most of the illustrations were done by our Art Director Leng Soh.

"We went for the cheapest printer we could find and worked from there. We chose the cheapest paper with the nicest feel, which was a bulky wood-free stock. Including hand-torn pages would normally be very expensive, but we and all the band members sat together to tear the paper and slot in the pictures, and we finished in one night. The torn pages were sold to a recycling plant for a token sum."

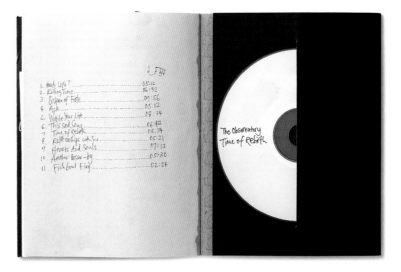

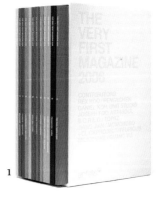

DESIGN FIRM:

Milkxhake

CLIENT:
Antalis Hong Kong;
paper manufacturer.

PROJECT:
The Very First Magazine
calendar magazine.

Javin Mo, Creative Director, Milkxhake:
"To most Hong Kong clients, budget is one of the most important elements of design projects. In general, people still do not respect the graphic design profession here—even some of the big commercial clients—compared to the situation in Europe and Japan. This helps to explain why not many local graphic designers can show strong portfolios.

1–2 The Very First Magazine was a calendar in the form of a boxed set of 12 magazine/diaries, each designed by an up-and-coming Asian designer or studio.

3

4

"Everything moves quickly here, including the practice of graphic design. Clients often provide insufficient time and a low budget in order to accomplish projects quickly. That is the Hong Kong culture, and it is quite difficult to change this attitude, which has existed for many years.

"Our studio has been involved in several low-budget projects, particularly for local nonprofit arts and culture organizations. This happened only when the client made clear their budget concerns before the start or the project involved a high degree of creativity. In general, we would let them know our normal budget first.

5

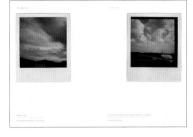

3 Spreads from the January issue, designed by Rex Koo of Hong Kong.

4 Spreads from the February issue, by Peng & Chen of China.

5 March, designed by Daniel Koo of Singapore's Unit Studio.

"We would only do 'no budget' projects with 100% creative freedom. In summer 2005, the first year of establishing our studio after I came back from Fabrica in Italy, we had a chance to work with Antalis Hong Kong, one of the biggest local paper companies. We were commissioned to design a calendar for 2006, which would be sent as a New Year gift to the company's customers, including renowned local design studios and advertising agencies. As the project offered us 100% creative freedom and reached out to the most prominent local creative people, we said 'yes' to the project. The only concern was the absence of a budget for design.

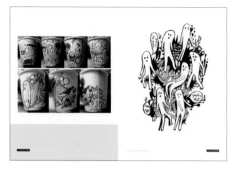

6 7

8

6 The April edition, designed by Joseph Foo of Art4Soul in Malaysia.

7 May, designed by B.O.R.E.D. of Thailand.

8 Spreads from the June edition, by Topaz from Hong Kong.

"From the very beginning, we were keen on designing a totally different form of calendar based on the client's two key conditions: that it should be sent out by its five branch offices in South East Asia in Hong Kong, China, Singapore, Malaysia, and Thailand; and that it should include more than 30 of the company's paper products.

"We immediately thought of combining the concepts of calendar, magazine, and 'visual diary' in a New Year 'calendar magazine' box set. It was to be launched on the first day of 2006, so we named it *The Very First Magazine*.

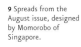

9 Spreads from the August issue, designed by Momorobo of Singapore.

10 The July edition, by Jiang Jian of China.

11

"We invited 12 young designers from the branch office regions to design their own issue based on an assigned month of the year. They were asked to explore their personal thoughts and creative views on the medium of paper. Each issue combined three main sections: the contributor's work (each page represents a day in the month); the designer's interview; and a visual diary for users to write and draw in.

12

11 The September issue, by +Clickproject of Malaysia.

12 October, by fFurious of Singapore.

"The final product was produced as a limited-edition box set of 1,000 copies released in five cities. It received lots of attention in the local creative industry and caught the attention of creative people and design press coverage in the target cities. *The Very First Magazine 2006* also won numerous design awards, including bronze in Graphic Design in China 2007 (GDC07). It received merit awards at the 86th New York Art Directors Club Annual Awards and the British D&AD Awards in 2007."

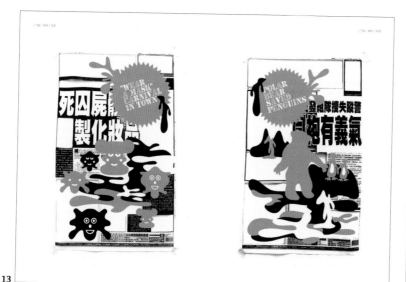

13 November, designed by Milkxhake.

14 Spreads from December, by China's Guang Yu.

DESIGN FIRM:
Number 17

CLIENT:
Self-initiated.

PROJECT:
Promotional Christmas
holiday gifts.

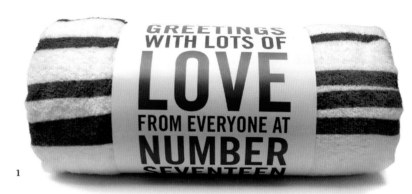

1

Bonnie Siegler, Chairman, Number 17:

"Finding elegant solutions with low budgets is very satisfying. We are never frivolous with other people's money and don't usually create solutions that require huge budgets to produce. For us, the idea always drives the solution, not an expensive embellishment.

"Every year, we try to send a Christmas gift and sometimes we succeed. We should start thinking of ideas in August, but we usually start in October. We always decide on the present when it's so late that everything has to be ordered or printed or manufactured on a rush basis, which adds to the stress. The benefits are that since we do it quickly and cheaply we have to go on gut reactions and often invent new ways to package things (like the scarf).

"We started in 1993 with T-shirts. There were three versions; each had a number (not 17) and then the words 'Number Seventeen' written next to that non-17 number. It cracked us up, but we think other people were confused by it. Our favorite thing about this package is that since the T-shirt had a racing quality about it, our return address said our office was in 'Vrooom 650.'

2

1–2 Thinking of a Christmas gift for hundreds of business contacts and friends that doesn't cost a lot—such as 2007's beach towel—is the challenge that faces Number 17 each October.

"In 1995, we missed Christmas, so we sent out a Valentine's card instead. It was a temporary tattoo that said 'LOVE NO. 17 STYLE' (a parody of the logo from the old 1970s show, *Love American Style*).

"Our knit cap in 1996 was the beginning of our winter outfitting string of gifts. We designed a No. 17 logo for the patch on the front of the hat that was supposed to look like a Super Bowl logo. We thought that was cool; we thought it would be great to send them all out in clear, heat-sealed bags so that everyone could see the hat right away. We silkscreened the message on the see-through bag and

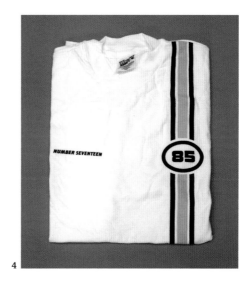

4

3

3–4 The "confusing" multi-numbered T-shirt of Christmas 1993 and its packaging.

5

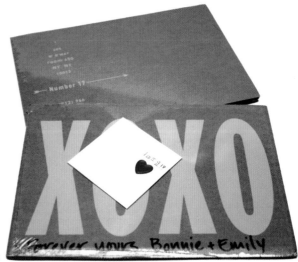

6

7

8

it was terrific. And then we mailed them. Guess what? During the course of the winter, we saw complete strangers, who maybe worked for the Post Office, wearing our hat around town, and clients who never got their hat. It still made us happy. But that was the last see-through package we sent.

"The hat was a success, so we decided to stay with knitwear in 1997. We decided on a scarf, probably because we could write our very long name all the way down one side. But we wanted it to be something that anyone we sent it to would wear, whether they were a CEO, a student, or somebody's mom. So we decided to go subtle—really subtle. We made it so subtle that the knitwear company thought we had made a mistake. One of our favorite things about this present was how it was packaged. We rolled the scarf up in a long sheet of white corrugated cardboard, like

5–6 The Valentine's tattoo and card that stood in for 1995's Christmas gift.

7–8 The Super Bowl-style knit cap and transparent packaging that proved popular among some postal staff in 1996.

a jellyroll. We wrapped a belly band around it with the return address and then shrink-wrapped the whole thing.

"After everyone got the scarf, we were amazed by how many people said, 'So what are you going to do next year, socks or mittens?' Then the next year we were very busy, and by the beginning of December we still had no gift to send. So we had the idea to buy ourselves some time. We sent out a card that told people they could choose their present themselves: socks or mittens. Then, in small print, it said: 'Please allow 6–8 weeks for delivery.' During that time we made an equal number of socks and mittens. People loved the interactive aspect of the whole thing and

everyone got their actual present when no other present was arriving. We think it was appreciated a bit more because of that. And happily it split pretty evenly in terms of who wanted what.

"In 1999, we were tired of knitwear and we were late again. But we couldn't pull the same trick, so we came up with a different one. We asked people, via postcard, to tell us what they thought was the greatest invention since 1872 and that the invention that got the most votes would be sent to everyone on the list, with a few disclaimers and a lot of suggestions. In the meantime we were having the thermoses made.

9 The "subtle" scarf of 1997, and its corrugated board packaging.

10–12 1998, and the stalling tactic of asking recipients to choose between socks and mittens for their gift.

"The cards people sent back were great and—wouldn't you know it!—the thermos won. People did really vote for it.

"In 2000, we decided to do something easy and on time. Again, our goal was to make a smart, functional, beautiful keepsake. We created a simple umbrella design that was at once like a color-blind test and representative of rain or snow. All we did for packaging was print two different stickers, one to go on the umbrella and one to go on the tube we were shipping it in. Easy, clean, and simple.

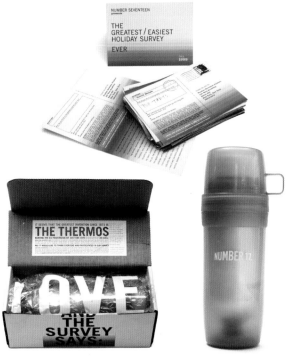

"2002 was the height of the *Sex And The City* craze and we had just finished the new coffee-table book about the show. We were able to buy the books at cost, so we decided they would make a great Christmas present. We found that they make that bumpy foam for packing cameras in pink and we found the right-size box. We figured that most people on our list would want one or know someone who

13–14 The surefire winner of an umbrella in 2000.

15 The thermos of 1999, as voted for by Number 17's mailing list.

would want one, so we silkscreened the offer to freely regift on the inside of the box. We also added a bookmark. We had one made out of ribbon at a place that makes prize ribbons.

"In 2005, we did a pillow. One side says 'Number Seventeen' and the other side has our phone number on it but it was designed to seem, at first glance, like a beautiful print made of random letters and numbers. Some people only realized it was our phone number after it lived on their couch for six months. We wrapped it with a ribbon and tied an envelope with a mint in it to the ribbon.

"We sent out a beach towel in 2007. Instead of *Christmas in July* (an awesome Preston Sturges movie), we decided it was July at Christmas. We got a chance to say something about global warming too. The design on the towel changed during production. At the last minute we realized we didn't like the original idea and made something completely new. It was scary to do that, but we ended up happy with the final product."

16

17

16 2002's "Sex And The City" book (designed by Number 17).

17 The Number 17 pillow of 2005, complete with phone number.

Graphic designers rarely work in isolation from other creative disciplines. There is usually a photographer or illustrator to brief, or a writer to supply the words. These can be arms-length relationships or involve side-by-side collaboration.

Occasionally, a project will come along that pushes a designer a little further along the sliding scale of collaboration and learning; one where they must soak up and apply knowledge from outside their usual sphere of practice. This chapter is about stepping outside the traditional comfort zone of designing pages and dealing with printers. It is about becoming editors, curators, and product designers, and collaborating with photographers, architects, and musicians.

For Browns, a design group intensely interested in testing the conventions of book and publication design, as well as in developing their own imprint, filling the role of editor/curator is simply a natural progression. Their edit of images for a book of photographer David Stewart's work acted

NEW TERRITORY

as a spur for the creation of new images, quite different from Stewart's older work. Javin Mo of Milkxhake was similarly invigorated when he edited, wrote, and designed a collection of new graphic design from China.

Coast and Mario Eskenazi report on successful collaborations with architects. Many architects undervalue the contribution of graphic design to the experience and enjoyment of the built environment, but it's clear that, where there is a meeting of minds, sparks can fly in the most positive, creative way. For the "Building(s) For Europe" exhibition, Coast set out to create a "bridge between graphic design and architecture" by containing all visual information within a system of boxed display panels and signs. Eskenazi, an architect by training, enjoyed a "fluid" relationship with both architectural practices involved in the Barcelona Forum Complex—a crucial factor in successfully designing a single signage system to complement their two contrasting buildings.

Kinetic and Number 17 both delve enthusiastically into the world of product and packaging design. Pann Lim embraced the opportunity to "dress up" Eero Aarnio's classic Puppy by resisting mere decoration and enjoying the learning curve involved in giving the plastic dog a new, unexpected function. Number 17's first excursion into packaging design—for Homemade Baby—was just as much an eye-opener.

DESIGN FIRM:
Browns Design

CLIENT:
David Stewart, English photographer.

PROJECT:
40 Shades of Black book.

40 Shades of Black. David Stewart

1

Nick Jones, Partner, Browns Design:
"David is a photographer best known for his surreal, humorous large-format portraits. His work has been exhibited at London's National Portrait Gallery as part of the Photographic Portrait Prize several times, and his 2007 entry, *Alice & Fish*, featuring his 14-year-old daughter, was shortlisted for the overall prize.

"David wanted to produce a book to showcase his work and approached Browns to bring it to life. He came to us with a number of images he had been working on to develop his own personal/artistic side as opposed to

2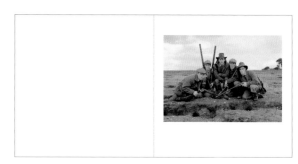

1 Front cover of "40 Shades of Black," a book of photographs by David Stewart, published and designed by Browns.

2 Spreads from the book.

his more recognized commercial work. He had shot a number of new images and brought along some older stuff too.

"Much can be read into David's work. There is often more detail than first appears and the images are often ambiguous, leaving the viewer to ponder the truth within. David wanted to include text in the book that reflected this, so he was introduced to the equally surreal and humorous writer Peter Kirby, formerly a creative director at ad agency HHCL.

"We took the childlike observational quality in his images as a starting point and based the format on children's board books. David is very visually literate, so his points of reference on color, type, and material were great. Each time we met we took a big leap forward. As the project evolved, our role extended beyond that of designers to include a curatorial capacity, deciding what should be in the book and what should not. We encouraged him to lose the older work, which was a little jokey. He shot more images as he gained a clearer idea of what he felt worked.

3
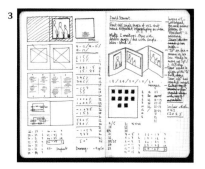

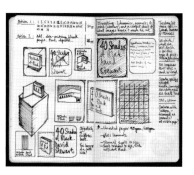

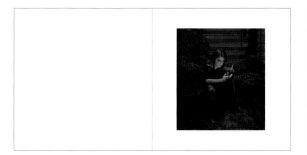

3 Sketches in which the format of a child's book with a thick board cover was first ventured.

4

"The biggest challenge was to try to keep a pace to the project. To that end, we imposed a deadline for David to finish shooting and for us to release artwork to the printer in China. We had to go there because no one in Europe could do it for us at a reasonable cost. Plus, all the specialist machines needed to produce kids' books have been shipped out there.

"There are actually only around 20 images in the book, but we wanted to create something that had a solidity and objectivity to it, and the thick board allowed for a certain 'thud factor.' Once this format

4 More spreads from "40 Shades of Black."

was agreed we wanted to carry this through, so we started the imagery on page one rather than starting with half-title pages and a list of contents. The size selected was 280 × 280mm [11 × 11in], square in format to accommodate both portrait and landscape images. Kirby's text appears on the center spread, with text on David on the back cover.

"We've produced a number of books of artists' work now, and our approach with all of them is that the photography, illustration, or whatever is the hero and should be shown in the best possible light. The pure Browns design bit, if you like, is in what goes on around the work: the cover, foreword, imprint, and any additional pages other than those showing the artist's work. Then, of course, there is the practical stuff of selecting a format, print techniques, binding, materials, typeface, and delivery mechanisms.

"Recently we have talked at length about pace and white space around artworks. The monotony of one image per spread (plates, if you like) allows the imagery to breathe and lets the viewer focus more on what's going on in the shot than if it were cropped a bit or full bleed. It's about less design over more and having the confidence and skill to do that."

DESIGN FIRM:

Coast

CLIENT:
The European Commission, with support from the King Baudouin Foundation, the Fonds Quartier Européen, and the Brussels Capital Region.

PROJECT:
"Building(s) For Europe" exhibition; project in collaboration with Joël Claisse Architectures.

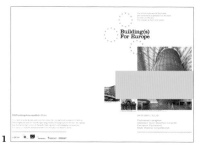 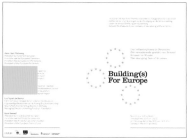

1

Fred Vanhorenbeke, Partner and Creative Director, Coast:
"The secret of working with other creatives is to respect their discipline as much as yours. Respect their ideas and their conception of the work. Working with another discipline is always a plus; it brings something more to a project, and that is really true with architecture.

"In the case of the 'Building(s) For Europe' exhibition, the working relationship with the architect Joël Claisse was very positive, with mutual respect. The exhibition was part of the celebration of the 50th anniversary of the Treaty of Rome. It was an initiative of the European Commission, the King Baudouin Foundation, the Fonds Quartier

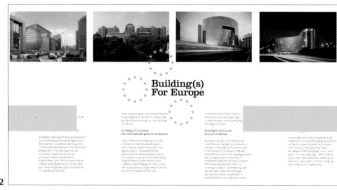

2

1 Invitation (front and rear) to the "Building(s) For Europe" exhibition, celebrating 50 years of EU architecture in Brussels.

2 Flyer.

Européen, and the Brussels Region. They asked Joël Claisse Architectures to create an exhibition on the subject of 50 years of EU architecture in Brussels. Writer Thierry Demey provided the text (which was adapted from his book on the same subject), and we were asked to create the overall look of the exhibition and the communications campaign, including posters and invitations.

"We met the architects first. From the start, we knew that we could have a very open creative discussion with them. There were no boundaries in terms of creative thinking—each partner could talk openly about the project.

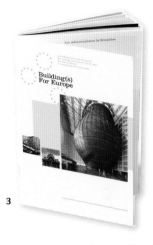

3

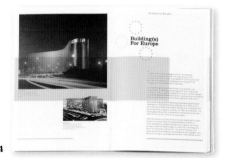

4

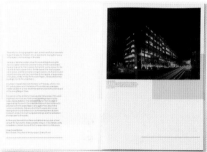

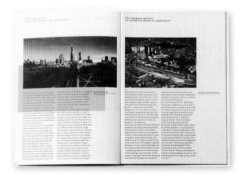

"They liked our ideas and adopted some of our ideas about the environment, such as the global yellow neon lighting (the yellow of the stars in the European flag). We took the opportunity to make the signage system more architectural, to create a bridge between

3–4 The exhibition catalog.

architecture and graphic design by creating a system of Plexiglas boxes on which die-cut mirror vinyl typography was placed. All of the building models were presented in these boxes, too. These and other volumes were the only places that there would be graphic design. We decided at the start not to put any posters or typography on the walls.

"The architects asked us for some minor changes, but the presentation we made to the client after that was almost the same.

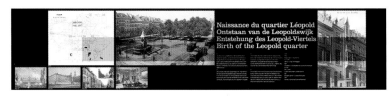

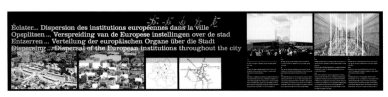

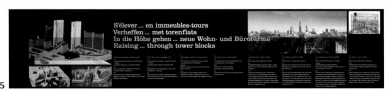

5

6

"Our presentations always show projects in as much detail as possible. We do this to reassure the client that we have understood the task, and to demonstrate that our solution is workable. When they understand our approach, they feel that even a minor change might destroy the job. Even if they do want to change something, we discuss it and, in 90% of cases, our proposition remains intact.

"At our first presentation to the board of decision-makers, decisions had to be made very quickly. However, only small visual changes were needed.

5–6 Typical exhibition panels.

"The biggest challenge was to make it happen on time and to budget. A lot of press and officials were being invited to the opening and there was a battle to make the exhibition possible financially. The budget calculated before the project was a bit short, so we had to find affordable solutions and people ready to work for less than normal.

"You have to respect boundaries when working with other disciplines: always stay in the field of competence you have been asked to provide and understand the principles of the other discipline. The key to success is to achieve a blend of both disciplines, and that happens when each one listens to the other. We still work a lot with Joël Claisse; we're doing two books with them at the moment."

7

7 Exhibition displays showing the system of Plexiglas boxes and mirror typography.

DESIGN FIRM:
Mario Eskenazi

CLIENT:
Infrastructures del Llevant
(Barcelona S.A.).

PROJECT:
Signage system for the Barcelona
Forum Complex.

2

Mario Eskenazi:

"I had never worked with architects before this project. It was an interesting experience because I had to work with two different architects' studios at the same time. One was Herzog & de Meuron, who designed the Forum Auditorium; the other was Jose Luis Mateo (one of the main architectural practices in Spain), who designed the Convention Center. Both buildings together form the Barcelona Forum Complex.

"The Barcelona Forum project was put forward by the Barcelona City Council, partly as a way to re-energize the city after the Olympics, and also to help develop and regenerate a whole area to the north of the city near the Besos river and along the Mediterranean coastline. The project was called the Universal Forum of Cultures, and its main theme was cultural diversity. It will take place every four years in a different city in the world; the most recent took place in Monterrey, Mexico.

1 The other half of
the Barcelona Forum
Complex, the
International Convention
Center, designed
by Jose Luis Mateo.

2 The entrance of the
Barcelona Forum
Auditorium, designed by
Herzog & de Meuron.

"There was one client, a temporary company that brought together the Barcelona City Council and General Location (a French company that would own the buildings after the Forum). However, the two architects' studios involved also needed to give their approval to the design project, and their opinion was crucial.

"The main challenge was to create an efficient signage system while respecting the architectural space. This was, on one hand, a convention center that would hold 30,000 people and, on the other, an auditorium for 3000 people. The main requirement was to design a signage system that would allow this huge flow of people to circulate effectively within the space. The second requirement was to unify the two buildings spatially. The two buildings were quite different from each other, and the signage was to be the main unifying factor.

3

4

5

3–5 Signage and informational symbols around the Convention Center.

"H&dM's initial suggestion for the signage was to use a handwritten typography, because one of their main concerns was to distinguish it from airport signage. My reaction to this was that, given the context of this being a huge international convention center as well as their own building for the auditorium, this would have presented readability issues.

6

7

8

6 Example layouts for the signs

7–8 Lettering on the side of a crate of building components inspired the signage typography by suggesting the human activity of painting signs.

9

10

11

"However, I interpreted their request as a concern with making the environment human and personalizing it. My proposal was to use stenciled typography, because that suggests the actual painting of the signs and the person involved in that process. I designed (in collaboration with Andreu Balius) a special font based on typography that I found on the side of a wooden box that contained some custom pieces for the structure of the building.

"What varied between the two buildings was the way in which the signage was applied, as well as its support. In H&dM's building, which is more 'brutalist' in character, the signage was painted directly on the walls, as if it were grafitti. Also, once the whole system had been designed, H&dM also asked for it to be applied to the auditorium seats, which had been specially manufactured in Milan.

12

9–11 Signage by Mario Eskenazi based on stenciled typography, applied direct to the walls inside the auditorium.

12 Auditorium seating, specially numbered with the new typography.

14

13

"In the other building, which was more high-tech, the signage was applied on aluminum sheets, as well as on aluminum walls and wooden doors.

"In the convention center, Jose Luis Mateo had planned some plain glass walls with lighting. He really loved the design system and the typography, so he asked me to put something up on the walls. His first idea was a directory of the building, but I thought there was no real need for that. So I suggested writing the various articles of the Declaration of Human Rights, which fitted with the whole theme of the Forum events. The articles were written in Spanish, Catalan, and English.

13–14 Large-scale signs on aluminum sheet walls.

"The project worked out quite seamlessly. I have no idea if it was successful, but I hope nobody got lost. I would happily work with architects again—it was a great experience, and I like signage projects very much.

"In my experience, there is a mutual respect between architects and graphic designers. While working on this project, our relationship was very fluid, perhaps in part because I am an architect myself by training, and this made it easy for me to understand the architects' approach."

16

15 Mural displaying articles from the Declaration of Human Rights in three languages, with the signage typography used for text.

16 Example layouts for signs and the typographic alphabet developed for the Barcelona Forum Complex.

DESIGN FIRM:

Inkahoots

CLIENT:
Collective Futures Group;
collaboration of Australian artists
and creatives.

PROJECT:
Fundamental Sounds live musical
and visual event.

2

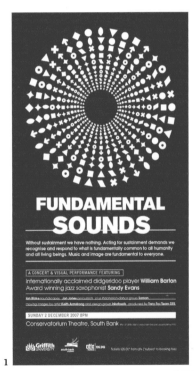

1

Jason Grant, Designer and Director, Inkahoots:
"The main point of this project was also a kind of parallel for the
collaboration—finding and fostering common understanding. The
challenges of collaboration are hopefully about supporting everyone's
unique expertise and building on what we have in common.

"Fundamental Sounds was a concert and visual performance celebrating
sustainability, which took place on Brisbane's South Bank on December
2, 2007. It was the first of what we hope will be a series of projects that
acknowledge cultural change as at least as great a priority in tackling
global warming as environmental technology.

1 Poster for the
Fundamental Sounds
event, featuring
Inkahoots' widely
radiating identity.

2 Stills from the
moving-image piece
developed for the event
with video artist Keith
Armstrong and others.

FLESH OF THE WORLD
THAT MEANS THAT MY BODY IS MADE
OF THE SAME FLESH AS THE WORLD...

AND WITH WATER WE HAVE
ALL LIVING THINGS

AND MOREOVER THAT THIS FLESH OF
MY BODY IS SHARED BY THE WORLD,

ALL LIVING THINGS
THE QUR'AN 21:30

MY LIFE LIVES IN THE MIDST OF YOURS

WE CANNOT BE WITHOUT OTHERS
I DEPEND ON YOU MY HUMAN

THOSE WHO SEEK GOLD
DIG UP A GREAT DEAL OF EARTH
AND FIND LITTLE

WE CANNOT BE WITHOUT OTHERS
I DEPEND ON YOU MY HUMAN
AND NON HUMAN FRIENDS.
MY LIFE LIVES IN THE MIDST OF YOURS

"The group behind Fundamental Sounds consists of design theorist Tony Fry, cultural critic Anne-Marie Willis, hybrid media artist Keith Armstrong, architect Jim Gall, and Inkahoots. It began as an idea from Tony and we quickly developed into the Collective Futures Group. We held regular meetings at Tony and Anne-Marie's farm in Ravensbourne, eating scones with jam made from rosellas from the garden, and interrupted with the occasional boot-throwing contest.

"As Tony Fry put it: 'How we live, communicate, relate, and celebrate—all these human elements must be considered when we talk about sustainability.' So the narrow framing of sustainability as just an ecological issue needs to be challenged by artists, designers, musicians, and writers, as well as scientists, if it's to be tackled effectively.

"The idea behind the event is that music is fundamental across all cultures; it's one of the deep things that sustains us. The sounds and images created for the event aimed to express that we need to break from the way we've felt, thought, and acted in the past.

"Because the budget was so restrictive, the identity needed to be illustrative enough to function as the central image on promotional material. The logo came from images we had previously developed that visually expressed emanating energy. This version suggests sound from a speaker, built from rotating concentric circles of basic (fundamental) shapes.

3

4

3–6 Further stills from the video by Inkahoots, Keith Armstrong, and others.

5

"With Keith Armstrong we created a projected moving-image piece that combined animation, Keith's video work, and animated typography based on a script by Tony. A soundtrack was improvised live by Ian Blake and Jon Jones. Didgeridoo player William Barton and saxophonist Sandy Evans also performed along with Indonesian dance group Saman.

"The biggest pleasure of the collaboration was learning stuff, and creating something valuable that wouldn't have existed with our expertise alone. What we learned was that collaboration can itself be a subversive activity in an industry that idealizes competitiveness and individualism."

6

DESIGN FIRM:

Kinetic

CLIENT:
Xtra Living; high-end furniture store in Singapore.

PROJECT:
Woof! Love charity fundraising event.

Pann Lim, Creative Director, Kinetic:

"We were approached, along with 11 other prominent local designers and artists, to 'dress up' Eero Aarnio's famous Puppy to raise funds for a charity group, Action for Singapore Dogs (ASD). The project was called Woof! Love, and it was organized by Xtra Living, a high-end furniture store that carries furniture by manufacturers like Herman Miller and Magis. It was inspired by a charity event in Miami, in which 30 of the world's best-known designers, artists, and architects decorated 'blank' Magis Puppies however they wished. Participants included people like Herzog & de Meuron, Jasper Morrison, Ingo Maurer, and Marcel

1

1 Watchdog, the Puppy designed by Eero Aarnio and adapted by Pann Lim for the Woof! Love project.

Wanders. All of the proceeds from the auctioned Puppies went to the University of Miami Sylvester Comprehensive Cancer Center. For this project, I was given the Puppy and an open brief to do whatever I wanted to it, with a deadline of one month.

"I believe in putting ideas into every little thing I do, so instead of just painting the dog or changing its form, I thought about the relationship between man and dog. That's how the Watchdog idea originated. The dog is more than just man's best friend. It is our guardian, protecting us and watching over our families. This intrinsic nature of the dog led to the idea of incorporating a tiny surveillance camera in the Puppy. When it is connected to a surveillance TV, the Puppy becomes a watchdog.

"I have always been intrigued by objects and product design: I love to read books on objects and furniture. But I had never designed an object before, and the stress of having to 'redesign' an object by a legendary designer like Eero Aarnio (designer of the iconic Ball chair from 1966) did not make the job any easier.

"I looked through his work and found that most of it is iconic and fun, yet minimalistic. I told myself that I would not 'mess up' his design because I totally respect what he does, so my solution of adding a camera only means adding a black dot to the puppy, giving it a 'nose'. It did not change the look or character of the puppy, but at the same time, my idea still comes across strongly.

"It was a fantastic learning curve, having to source a small camera, drilling the puppy and installing the wires and so on myself. It was very satisfying to see the end result the way I'd envisioned it. "The project was covered in newspapers and magazines, and it helped to raise funds for ASD."

DESIGN FIRM:

Milkxhake

CLIENT:
3030 Press; publishers.

PROJECT:
3030: New Graphic Design in China book.

1

2

Javin Mo, Creative Director, Milkxhake:

"This project started in 2007 when John Millichap, the publisher of 3030 Press, approached me directly to see if I was interested in editing a book about the emerging graphic design scene in China. Released by 3030 Press, the first title, *3030: New Photography in China*, featuring 30 young photographers under 30 in China, was successfully launched in 2006.

"3030's second title, *3030: New Graphic Design in China*, was published in 2008. The book is an illustrated survey of the work of 30 of mainland China's most exciting young designers around the age of 30. The book revealed a new concept of creativity in China in which the opportunities of astounding economic development negotiate with the legacies of tradition and ideology. The generation of designers, born during the 1970s and 1980s, have grown up in a different kind of China from that of their parents.

3

1 Front cover of "New Graphic Design in China." **2** Back cover.

"These changes have included a massive rise in living standards and personal wealth; a relative increase in personal freedoms; and, perhaps most importantly, a shift away from ideas of collectivism toward individualism and consumerism. The introduction of the One-Child Policy, which is applied in China's cities most rigorously, has also had the effect of focusing an entire family's attention and resources on just one child, who is then much better able to afford schooling at foreign universities and overseas travel.

"The effect of the internet, which launched in China in 1995, has had an especially profound impact. More than 1,000 mainland designers' portals, blogs, and individual websites created since 2000 have connected design communities with each other, not only in China but all over the world. These exchanges have allowed China's new designers not only to plug into the latest ideas but have also stimulated an impulse to create their own distinctive place in the international design landscape.

3 Spreads from the book, featuring work by some of the 30 Chinese designers spotlighted.

"Since 2004, I have participated in many young designers' shows and exhibitions in China. One of the most important was the first 'Get It Louder' exhibition in 2004. It was the first group show in China featuring more than 100 young creative people across various disciplines, and was launched in Shenzhen, Shanghai, and Beijing.

"Since then, I have been in touch with many young designers' creative happenings in China, and we have become good friends. Hong Kong stands between East and West; I could easily connect with both the

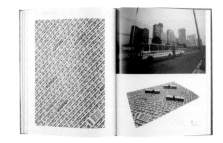

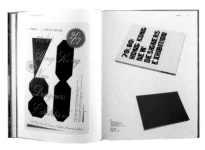

4

Chinese design community and overseas creative networks, so I was in a good position to curate a book about new Chinese graphic design.

"My duties on the book involved selecting and interviewing designers and interviews, collecting and selecting works, editorial direction and graphic design, as well as printing and production follow-up.

"The selection of designers and their works was the most challenging and inspiring. The development of graphic design in China is still something totally new to Western countries, but it is a popular profession there. Through the 30 designers, we covered 13 cities

4 Further spreads from "New Graphic Design in China."

in the book: Guangzhou, Shenzhen, Shanghai, Xiamen, Hangzhou, Beijing, Nanjing, Xi'an, Chengdu, Taiyuan, Ningbo, Changsha, and Zhengzhou.

"While I was curating the book, I had a chance to be part of the '70/80 New Hong Kong Designers' exhibition, a touring exhibition in China introducing

15 young Hong Kong designers. Visiting Hangzhou, Shanghai, Changsha, Chengdu, and Shenzhen made a big impression on me. Through seminars and discussion, I could feel a refreshing energy from those mainland young Chinese designers.

"The whole process of working on the book was amazing and fruitful. I have made some good friends and it gave me a chance to connect with some of the best local and international design journals and magazines. Their positive comments and book reviews were extremely encouraging.

"The project also allowed me to see design differently. A graphic designer often concentrates on a single project in a creative way, while an editor has to have a broader way of thinking over several disciplines, which is a very good training and development for designers. It definitely broadened my scope of thinking about multidisciplinary professions. A good designer could become a publisher or a writer; a photographer could become a fashion designer, or an architect could become a product designer."

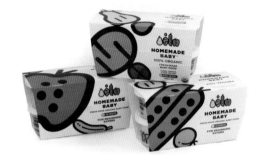

DESIGN FIRM:
Number 17

CLIENT:
Homemade Baby; LA-based
organic baby food manufacturer.

PROJECT:
Baby food packaging.

Emily Oberman, Chief Executive, Number 17:

"Homemade Baby began as organically as you might hope. A California
mom made such incredible baby food for her kids that everyone whose
children she shared it with told her she should start a business. It was the
kind of baby food where you would feed your baby a spoonful and then
treat yourself to a spoonful and back and forth until the bowl was empty.

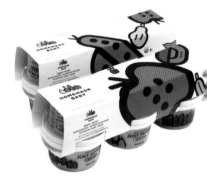

"This particular mom happened to be an executive at Lifetime Television,
for whom we had done some work. She called us and we got along
famously over the phone, and we started working on the identity
for the new venture.

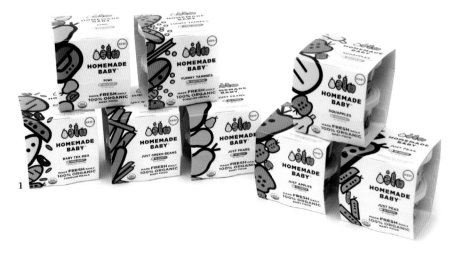

1

"The company is run by Theresa Kiene and her husband Matt. Our relationship is purely electronic, although we did actually meet Matt once when he came to New York on business. The product is fresh, organic, kosher, gluten-free, and vegan, and it is STILL truly delicious. Bonnie's son, Oscar, was the perfect age to focus-group all the flavors when the company was starting. He proved to be an insatiable client, as did the designers in our office. Sometimes the food got eaten before Bonnie could get it home to Oscar.

"We have designed amenities for hotels, but had never really designed food packaging before. We were very confident we could do it, but also, we think it can be very beneficial to a client to work with us on something we have never done before. In fact, that was one of the reasons they came to us in the first place.

"The company knew they wanted something very different from what was already in the market. We were all really excited about the job and approached it with a gusto we may not bring to something we've done a hundred times before. Also, we inadvertently invented new ways to do things, because we didn't know any better.

"We knew what baby food was supposed to look like and we knew what it was supposed to taste like, so we knew that Homemade Baby was totally different and that fact needed to be clear, at a glance.

1 Packaging for the Homemade Baby range, designed to make its presence felt on the organic baby food shelves.

2 The Homemade Baby standard "Usual Suspects" logo, a Christmas version, and a frozen version.

3–4 Patterns developed from Homemade Baby's fruit and vegetable line-up.

"They wanted a logo that immediately conveyed the difference between them and the other products around. The competition all looked alike, so we were certain we could stand out from the pack pretty quickly. We presented six different logos, each communicating a slightly different personality. We liked them all, but definitely preferred the fruit and vegetable one and so did the clients. From there we were able to fully invent the playful and pop-y persona.

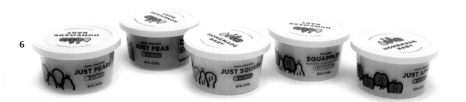

"The biggest challenge was printing on that damn little cup. We and Matt and Theresa had ALL never done this before, so we went through a few trials before anything could go to print. What kind of ink should we use? Should we print white behind it? How could we be certain the image would correctly fit on the cup?

"We'd never worked with a printer who only printed on plastic cups and lids before and they spoke a different language, so we had to learn that language.

5 An e-card to celebrate Homemade Baby's second birthday.

6 The biggest challenge: printing on the plastic cup containers.

7 Folders.

"Also, when Homemade Baby was first conceived, it was a mail-order business. The product was going to be shipped overnight, frozen fresh, and packed with freezer bags. We had to design the whole experience, from when the box arrived to when you open a pack to feed your baby.

"In the first version, the sleeve was printed on paper that was too light (not our fault) so the second the ice packs started to melt, the sleeves started to get wobbly and fall apart. In the end, mail order proved to be economically difficult for the client so they decided to try and go mass-market with it. On the bright side, we designed some great stickers for the shipping box that they still use now.

9

YUMMY TUMMY

OPEN WIDE

READY. SET. EAT!

NUM NUMS

HOMEMADE BABY

"The final product was a playful, bright, fun, clean package that said, from far away on the shelf, 'Not your mother's brand of baby food.' In the end, it wasn't naïvete that helped make it better, but rather not being jaded about the way something is supposed to be done. That, and good design, and the fact that the client was so open. They were open to us naming some of the flavors (and are to this day)—like Piwi, which is made from pears and kiwi.

"The design system that we created was very solid. It was flexible in terms of expanding the brand and constantly remaining playful and appealing. Over the years many designers have jumped in and done lovely work within this brand."

8

8 Pages from the website www.homemadebaby.com.

9 Stickers originally developed for Homemade Baby's mail-order operation.

"Rush jobs are really a state of mind," argues Bonnie Siegler of Number 17. Any project, no matter how well planned and anticipated, has the potential to mutate into a rush job. And it's not unusual to find designers who have difficulty functioning until a deadline looms large. The bona fide rush job is the 100-meter sprint, not the middle-distance race with the burst of speed in the final lap. It is short, intense, and leaves little room for subtlety (or sleep). It gets the adrenalin pumping and the nerves jangling. Intellect and ideas rarely have time to make their presence felt; what's needed most are cool heads and clear minds.

In certain industries—and certain parts of the world, such as Hong Kong—the rush job is the norm. Businesses in fashion, music, and broadcasting, for example, tend to think only in terms of the most immediate objective, whether it's the next collection, the next CD, or the next series. They move at their own pace and momentum; those from outside are expected to adjust. Every September, Number 17 is left just a

THE RUSH JOB

matter of days to create the opening titles for *Saturday Night Live.* But, as Bonnie Siegler points out, "They are used to creating 90 minutes of television in less than a week, so, to them, 90 seconds should be a breeze."

By contrast, Browns' rush job was a longer affair, but the demands of designing, writing, manufacturing, and delivering a necessarily luxurious "scrapbook" on the 50 catwalk shows of fashion designer Dries van Noten in just three months meant that it was no less pressured. The nailbiting climax of the project was the book's delivery to guests at the spectacular dinner that followed the 50th show—complete with photography from the show the guests had just seen.

Such projects, involving multiple suppliers and contributors, are as much a project-management challenge as a design challenge. Where possible, design groups such as Coast keep the number of creative inputs on a rush job to a minimum, and avoid involving photographers, illustrators, and other external specialists. For the packaging of DJ Ivan Smagghe's new release, Fred Vanhorenbeke created the main illustration himself.

The main misgiving among designers about the rush job is that it leaves no time to think. On rare occasions, such as Mario Eskenazi's creation of a typographic identity for the *Asterisco* series of books, the design solution appears instantly and no further thought or exploration is necessary. In most instances, though, expediency demands compromise: if it does the job, the job is done.

DESIGN FIRM:

Browns Design

CLIENT:
Dries van Noten; fashion designer.

PROJECT:
Dries van Noten 01–50 book.

Jonathan Ellery, Founding Partner, Browns Design:
"This project started with one of those emails you get
once or twice in a career. One of Dries van Noten's assistants
wrote to say that Dries would like to invite us over to his headquarters
in Antwerp, Belgium. Off I went with Philip (Ward, account director), not
knowing what to expect. Over lunch, they asked if we would like to
design a book to celebrate the 50 fashion shows produced by Dries van
Noten. It turned out that their studio had most of the books previously
designed by Browns on their shelves.

"While I was there, I was taken with how brilliantly considered every
aspect of the operation was, from how the coffee arrived down to how
every aspect of every show was catalogued in a shirt box. We wanted to
replicate the experience of opening these boxes and pulling out things
like fabric swatches, invites, drawings, and Polaroids. So we decided to
create a luxury scrapbook.

"We were encouraged to be ambitious with our thinking, as this was
a remarkable milestone for Dries to have achieved. To this end, an
elaborate six-page, case-bound cover was conceived with a half-title
page of gold paper and all pages gold gilt-edged to acknowledge the
50th anniversary.

1

1 How do you add
photography of a fashion
show to a book that has
to be printed before the
event has taken place?

Adding Polaroids of Dries
van Noten's 50th fashion
show to a lavish book
about the designer was
Browns' solution.

biography
interview
show specifications
information

2

Biography Dries Van Noten

The line met with almost immediate
success on its launch in 1986, selling
to prestigious customers like Barneys
New York, Pauw in Amsterdam and
Whistles in London.
 In September of the same year,
Dries Van Noten opened a tiny
eponymous boutique in Antwerp's
gallery arcade. Here he sold his
men's and women's collections,
which were initially made from
the same fabrics.
 His fellow students at the Academy
had included Ann Demeulemeester,
Dirk Van Saene, Marina Yee and
Walter Van Beirendonck, and the
group had maintained close contact
after graduation. In 1986, along with
their compatriot Dirk Bikkembergs,
they travelled to London and showed
together at the British Designer
Show, where they found international
recognition as the 'Antwerp Six'.
 In 1989, he quit his modest
boutique for a five-storey former

3

2–3 Pages from the
middle, informational
section of the book,
printed on bible paper.

"We had just three months from start to finish. That meant looking in each box, identifying what was relevant, then photographing each of these objects consistently, then the subsequent edit and selection. We were also designing the book in a scrapbook style, which is not about dropping things into a modular grid—each page had to be composed and crafted individually. We had to wait for fashion journalist Alix Sharkey, to pull all the stories together, and make sure they tied in with the things we had identified to shoot.

"There was massive pressure. Lisa, who designed it, was here till at least 2am most nights and did all-nighters on top of that over a period of about two months. We had someone else help her with scanning, running around, and so on, and Nick (Jones) ended up designing and artworking the central bible section. The finite deadline of Dries's 50th show dictated all of this. There was also a lot of copy to write, which put massive pressure on Alix, who was also doing his day job.

"But it was never not going to happen. It always comes together, whatever the project. Our team were too on top of it for it to go wrong, and Dries' team were very professional as well, having had extensive experience of 'last minute' in the fashion world.

"The middle of the book boasts a section on bible paper that contains detailed specifications of all shows and invitations produced since 1991, biographical information, an interview with Dries, and contributions from other special guests.

"The ambition of the gilt edges and six-page cover, foil blocking, and tail bands also put pressure on production. We had to see dummies of the book and make amendments, and because of all the color work there had to be a lot of proofing.

"It didn't end there. The book was commissioned with the aim of delivering 500 copies simultaneously to the great and good of the fashion world immediately after the 50th show. Which left us with a question: how do you record the 50th show in a book before it has happened?

"The answer was to place Polaroids of the show into transparency bags, and tip them into the books as the show progressed. So that cranked up the pressure.

4

5

4–6 Further pages from the "bible" section.

Show Specifications — What, when, where and who

no. 11 no. 13

Men's Collection Men's Collection
Autumn/Winter 1995 – 1996 Spring/Summer 1996

no. 12

Women's Collection
Autumn/Winter 1995 – 1996 no. 14

Women's Collection
Spring/Summer 1996

Show Specifications — What, when, where and who

Show Specification

no. 48 no. 50

Women's Collection Women's Collection
Autumn/Winter 2004 – 2005 Spring/Summer 2005

no. 49

Men's Collection
Spring/Summer 2005

"The next question was how to deliver the books simultaneously to all 500 guests. Each guest had a taxi to take them to a disused warehouse on the outskirts of Paris. They were all held in an anteroom and served canapés until everyone was assembled, and then invited to enter the main room where they were confronted by a table the length of a football field, set for dinner with 100 antique chandeliers overhead. Every course was served with military precision by 250 Belgian waiters. Once the meal had finished, the room was plunged into darkness and the chandeliers raised. The room was then illuminated to reveal models striding down the dinner table-cum-catwalk.

"As the final model left the runway, the room was again darkened save for a sharp spotlight on each setting, and all 500 books were lowered, on shelves, to the clamoring hands below. There was an audible gasp and wild applause, and as each person opened the book they were illuminated by the reflection of the spotlights on the golden pages. It was quite magical."

DESIGN FIRM:
Coast

CLIENT:
Eskimo Recordings; Belgian record company.

PROJECT:
Death Disco by Ivan Smagghe; CD packaging.

Fred Vanhorenbeke, Partner and Creative Director, Coast:
"Rush jobs are common in our studio. They're unavoidable: people want to see and have things very quickly. We don't have days and days for thinking any more; we have to act quickly.

"When they are well managed, rush jobs always produce good solutions. The client needs to be aware that on a rush job they have to play a constructive role. A destructive client—always saying no, demanding corrections, not sure of its strategy—can't play the rush-job game.

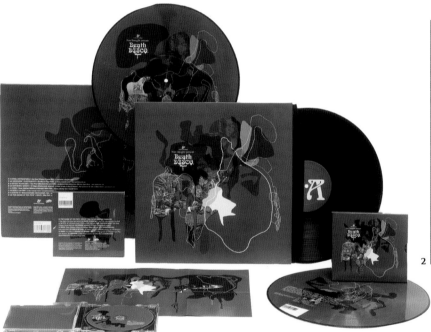

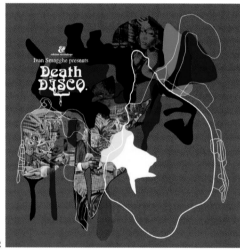

1 Packaging and discs for "Death Disco" by Ivan Smagghe, designed, approved, and printed in just a few days.

2 CD cover.

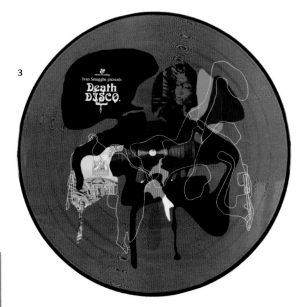

3

"Eskimo liked our work and gave us carte blanche. We'd worked on another project for them before this—the single 'Culture Club' by Polyester. For this project, they needed the CD, double vinyl LP, and poster designed in ten days. I responded very quickly as it was a great opportunity to create graphics for music—something I was doing back in my days in London at Stylorouge.

4

5

3 Picture disc.

4 The poster that came with the CD.

5 Detail of the vinyl back cover.

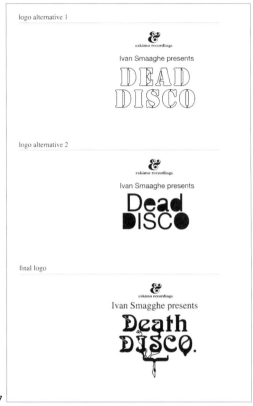

"*Death Disco* is Ivan Smagghe's fourth album, a mix of tracks showing the dark side of the dancefloor. The design had to be approved in a few days, then sent to press very quickly.

"When we have to act fast we do all the work here, without photographers, illustrators, or other specialists. In this case, I designed an illustration myself, drawing on paintings found in an old art book. The illustration is a visual translation of death disco: a mixture of a lifeform and death. It shows disco people in a dark moment. Details from two paintings (by an unknown artist) were scanned in and I played with them to reinforce their dual visual impact: people lounging by the pool, but with a sense of danger. The pencil lines are there to represent something empty, derelict. A haunted, decomposed object.

6 CD label artwork. With no control over the CD printer used, Coast included cropmarks and clear directions on the files to avoid confusion.

7 Two rejected logotypes and the one chosen.

8 CD artwork.

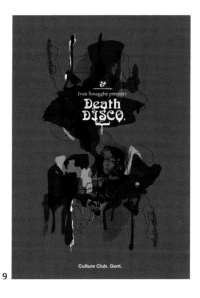

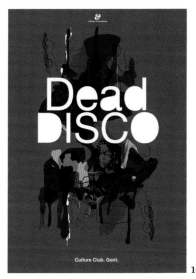

9

10

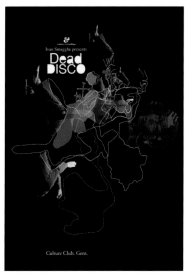

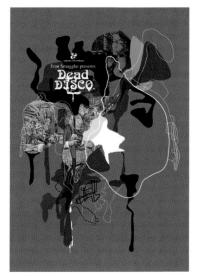

"Rush jobs are a time-management challenge and an organizational challenge. Each moment spent is important, and that keeps us very sharp. What's missing is the chance to step back and look. The bad rush job would be creating a piece of work that was unsuited to its client or audience because of a lack of appreciation time."

9 Draft designs for posters.

10 Sleeve designed in 2003 for Polyester, another Eskimo Recordings act, which inspired the "Death Disco" packaging.

DESIGN FIRM:

Mario Eskenazi

CLIENT:
Ediciones Paidos Iberica; Spanish publishers.

PROJECT:
Asterisco book series design.

Mario Eskenazi:

"I rarely do rush jobs. I have a small studio (four people including me), and we are always working on many projects at the same time. Accepting rush jobs within this context means affecting every other project on hand. It also makes me anxious!

"The rush can sharpen your thinking, I would agree with that, but it is not the issue. I really don't enjoy working under pressure. It's different from working quickly. I can be extremely productive and efficient, but I work best if I can relax while doing it.

1

Günter Grass
★★★★★★★★★★★★
Escribir después de Auschwitz
Reflexiones sobre Alemania: un escritor hace balance de 35 años
PaidósAsterisco* 1

Günter Grass
★★★★★★★★★★★★
Discurso de la pérdida
Sobre el declinar de la cultura política en la Alemania unida
PaidósAsterisco* 2

John Gribbin
★★★★★★★★★★★★★
El pequeño libro de la ciencia
PaidósAsterisco* 5

Pierre Bourdieu Loïc Wacquant
★★★★★★★★★★★
Las argucias de la razón imperialista
PaidósAsterisco* 6

Jean Baudrillard/ Edgar Morin
✳✳✳✳✳✳✳✳✳
La violencia del mundo
PaidósAsterisco* 9

Eric J. Hobsbawm
Coversación con Antoine Spire
★★★★★★★★★★★★
El optimismo de la voluntad
PaidósAsterisco* 10

Howard Gardner
★★★★★★★★★
Las cinco mentes del futuro
Un ensayo educativo
PaidósAsterisco* 11

Boris Cyrulnik Edgar Morin
★★★★★★★★★
Diálogos sobre la naturaleza humana
PaidósAsterisco* 12

STEVEN PINKER
★★★★★★★★★★★
LA TABLA RASA, EL BUEN SALVAJE Y EL FANTASMA EN LA MÁQUINA
PaidósAsterisco* 13

1 Front covers from the "Asterisco" collection of essays by world-renowned authors and philosophers, designed in a fortnight. Each title was distinguished by its own typography, but used only one color—black.

"Paidos is a publisher of humanities and social sciences texts, many of them textbooks for the academic market. On this occasion, nearly at the start of the academic year, Paidos secured the rights for some texts that would be perfect for students. They wanted to get them on the market as soon as possible to coincide with the start of the academic year. That meant I had two weeks to do the design of the covers and the interior for a new collection.

"I have worked with Paidos for almost 30 years. I met the CEO, Enrique Folch, through an acquaintance, and he then called me to design some book covers. We have developed a very close friendship over many years.

2 Typical interior pages.

"The new collection needed to be cheap to produce. The books were a single essay or article, by a single author. So they were quite small books, between 60 and 70 pages each, the spines between 0.3 and 0.5cm. Otherwise, it was an open brief. At the outset, there were ten different texts, but the idea was that it would be an open collection and would eventually have many more titles.

"In the end, the timescale had no influence on the design, other than exerting the need to come up with something easy to implement right away. At our first meeting, Enrique told me that the name of the collection would be *Asterisco* (Asterisk), and I immediately visualized the design solution. With my love of typography, it had to be based on an asterisk! It needed to be easy to produce in a hurry, and there needed to be a system in place that would allow new titles to be produced easily.

3

3 Front and back covers and spines from the "Asterisco" series.

"Because it also had to be cheap to produce, we used only one color—black. The system was to have a different typography for each title, and the author's name and the title would be separated by a rule made of asterisks. On the back cover, there was a large asterisk corresponding to the typography of the cover. If you look at the back covers of the series, you have a collection of different asterisks. On the inside, the top rule was also made of asterisks.

"At that time Diego Feijóo worked with me at the studio. We worked on this project together. I asked him to help me with this while he carried on with other projects. I explained the idea, and as it was very simple, he got it done very quickly.

"I'm extremely pleased with the result. I really love this collection. I don't think it could have been any better if we'd had more time."

DESIGN FIRM:

Kinetic

CLIENT:
Zuji.com.sg, Singapore-based
online travel agent.

PROJECT:
Promotional stunt.

Pann Lim, Creative Director, Kinetic:
"Rush jobs are quite common in our studio. That is, if a one-to-three-day turnaround counts as a rush job. The challenges of rush jobs depend on how tight the team is. From client servicing to the creative teams, everyone must work as one. If there's synergy, it's always pleasant to work together, even if it's a real rush. Of course, trying to come up with ideas in a short span of time can be really stressful. There are no fixed formulas to any brief that comes in.

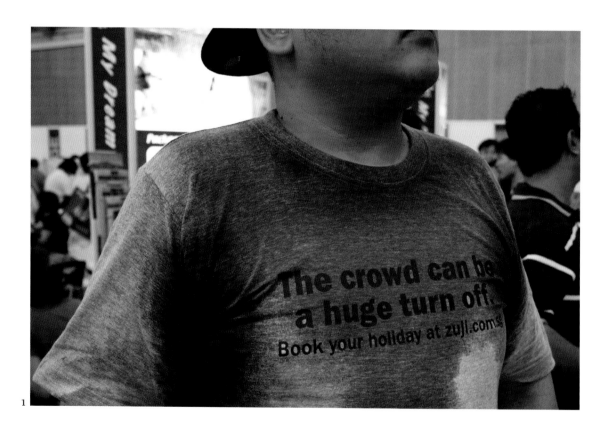

1

1 Rush jobs can be
sweaty jobs; this one, for
zuji.com.sg, inserted
large, perspiring men
into a travel fair to
persuade visitors to leave
the crowds behind.

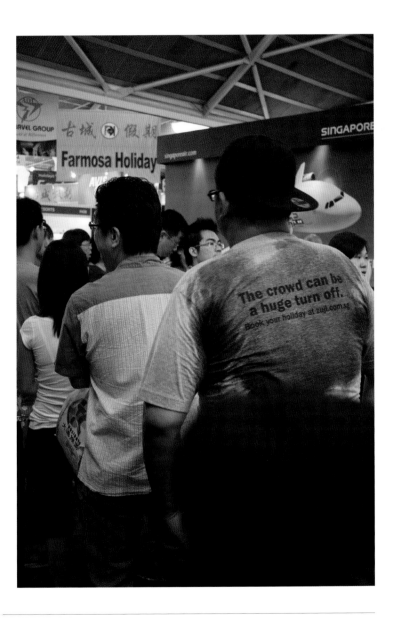

"Rush jobs can produce good solutions. There is no law that says more time means better work. That said, having a bit more time can help give the designers more time to explore instead of immediately saying, 'This is the direction, style, and concept. Let's go!'

"Level-headedness and experience come into play as well. We are not solving a mathematical equation where there is a finite answer. The creative brief usually presents a journey into the unknown; we are just finding a way to the other side, and there are many ways to get there. The question is, which way is the shortest? Which way is the most creative?

"This was a project that we proposed to the client, zuji.com.sg, an online travel agent. Every year there is a major travel fair in Singapore at which Zuji have a stand. These travel fairs are usually ridiculously packed. Everyone gets hot, tired, and stressed. Our idea was a way of reminding travelers that, instead of queuing up at the fair, they could go home and book tickets online with Zuji.

2

"During the peak hours of the fair, we would send a group of big, smelly, sweaty men off in T-shirts to squeeze through the crowds and jump queues, and generally cause discomfort and frustration among the visitors, in the hope they'd go home and visit zuji.com.sg instead.

"My designer thought of the idea two days before the fair. We contacted Zuji and they liked it, so we immediately started sourcing the 'actors', getting the copy written, and getting it printed on the T-shirts.

"Casting the sweaty 'actors' in such a short time was almost impossible. It was hard to find people who didn't mind looking dirty in public. In order to print the message on the T-shirts, we needed to know the actors' T-shirt sizes, so there was a hold-up in production until we found the 'actors,' at the last minute.

2 A damper on proceedings.

"There wasn't much design involved; it was more a copy-and-stunt idea. We wanted the message to be upfront with as little clutter as possible, so we went with a simple typographical layout.

"The time shortage did affect our decisions slightly. We were thinking of using light blue T-shirts with white silkscreening. But silkscreening in half a day is impossible, so we went for a decal transfer instead. In the end, the idea was still the same.

"It was great seeing travelers moving away from the sweaty men. A lot of them actually got the joke and idea. That made our day."

DESIGN FIRM:

Inkahoots

CLIENT:
AustLit (The Australian Literature Resource); nonprofit organization.

PROJECT:
Corporate identity.

Jason Grant, Designer and Director, Inkahoots:
"Most successful outcomes are probably a combination of research and intuition. I suppose a tight deadline could potentially spark instinct but hinder the more methodical imperatives of getting to know the subject and developing ideas.

"AustLit is a collaboration between the major Australian universities and the National Library of Australia. It provides comprehensive information on creative and critical Australian literature works from 1780 to the present day. The nonprofit organization indexes and describes Australian literature, and also makes available selected critical articles and creative writing in full text. Researchers, bibliographers, and librarians gather information about Australian writers and writing to facilitate access to Australian literature.

1

2

1 A poster that was part of Inkahoots' new look for AustLit.

2 Brochure cover.

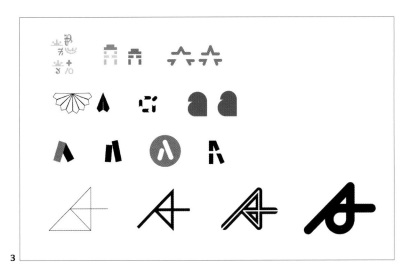

3

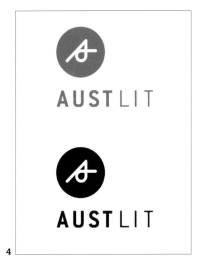

4

"Logo elements are combined within a pattern of authors' images, graphic panels, and text. So the vast coverage of the AustLit database is represented by blending carefully considered typography, modern-day photos, and classic paintings in a dynamic composition. The overall visual language hopefully suggests a rich mix of history, the contemporary, and the future.

"The thing that felt most rushed was probably the image selection. We needed to show iconic historical and living Australian writers from different cultural backgrounds. It might have been good to do some more research to find a spot-on palette of representative images."

"We were asked to create a new visual identity and applications including promotional material and a website. The design needed to be ready for a major conference, but the brief was pretty open: authoritative, contemporary, inclusive. Since it couldn't represent one genre or era, our initial research was focused on ideas about combining fragments of letterforms with different historical flavors to make a kind of monogram. But it didn't work out.

"We figured the identity needed to be distinctive and nonrepresentational, enabling it to absorb many ideas associated with literature and writing, rather than projecting specific symbolic qualities. The logo distils both a capital 'A' and lowercase 'a.' This hybrid is literally the beginning of the alphabet, and represents literature and writing generally.

3 Development of the AustLit symbol, finally arriving at a compound upper- and lower-case initial.

4 Versions of the AustLit logo.

DESIGN FIRM:

Milkxhake

CLIENT:
Organizers of October
Contemporary; Hong Kong-based
event to promote local artists.

PROJECT:
Event identity and applications.

Javin Mo, Creative Director, Milkxhake:
"Rush jobs are very common in Hong Kong, as
everything moves really fast here. We don't think it's
a healthy starting point for design. Half of our
projects are quite a rush; they might need to be
completed in two to three weeks.

"Sometimes rush jobs can be really challenging as you
have to make work that looks perfect in just a few
days. It might sharpen your design efficiency but not
your quality. It really depends on the designer's
perception. It would be great if you could always
have brilliant ideas for the rush jobs, but it doesn't
happen very often. A good design and solution
still take time to perfect.

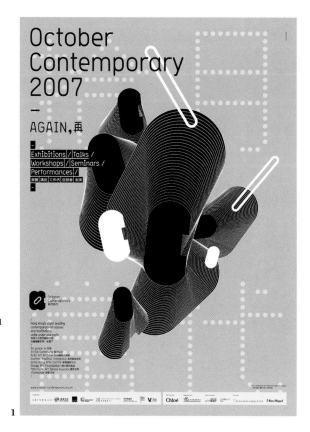

1

2

3

1 Milkxhake was given
two to three weeks to
get from ideas and
concepts to finished
printed items, including
this poster, and a
website, for the 2007
October Contemporary
art festival.

2 Postcards.

3 Business cards.

4

October
Contemporary
拾月當代

5

"It is difficult to explain why clients here give short timescales. It might be the local fast-food culture that sharpens their mentality. If you always work in a rush and under a huge pressure to meet tight deadlines, you will definitely lose your passion and interest for your job, because you'll have no life at all.

"October Contemporary is the first annual event dedicated to promoting contemporary art and artists in Hong Kong. In 2007, eight of the city's leading art spaces and institutions joined forces to present a series of exhibitions, talks, workshops, seminars, and performances for the month of October, to feed and develop current discourses on culture and the arts.

6

4 The "OC" logotype, from which the abstract imagery for the publicity was developed.

5 Postcard.

6 Pages from the festival booklet.

"We were commissioned to design the new event and visual identity. We had just two to three weeks to get everything done, from ideas development to event logo and final printed items, including posters, postcards, the event brochure, and a website. As it was a new annual festival with all new clients and committee members, the coordination of the launch was not very strong and the schedules were really tight.

"Our approach was to create a simple but strong visual identity that could be easily applied in any graphic or interactive medium in just two colors. After the first presentation, the client immediately approved our solution without any changes and we developed our design further.

7

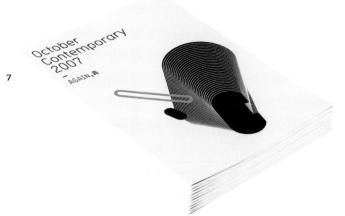

8

7 Brochure for the 2007 October Contemporary festival.

8 Spreads from the brochure.

"The event logo was a contemporary typographic interpretation of 'O' and 'C,' representing the fusion and blending of contemporary arts. Printing it in black and silver, we extended the logo into a collection of three-dimensional forms, which we then applied on the poster, postcard, brochure, and website.

"The client commissioned us to work with them on the same event in 2008."

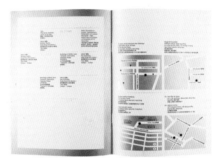

DESIGN FIRM:
Number 17

CLIENT:
NBC; US television network.

PROJECT:
Saturday Night Live opening titles.

1

Emily Oberman, Chief Executive, Number 17:
"Any job can turn into a rush job, and every job will grow to fill the time you have, so rush jobs are really a state of mind. That said, *Saturday Night Live* is always a rush job. You have to make quick decisions and stick to them. Oh, and also, for at least two weeks, you have to give up that full-night's-sleep concept.

"We both learned how to 'make television' in our previous jobs. Bonnie's first experience was at MTV and she later became design director at VH1. My first experience was designing a music video for Talking Heads while working at M&Co; then I went on to do most of the television projects there. When we started Number 17, about half of our work was in television.

1 2007–8 opening titles
for "Saturday Night Live."

"We have been working with *Saturday Night Live* since 1993. We have both been huge fans of the show from the very beginning and we were very lucky that a friend of ours, who was writing for the show, recommended us to do some work with them.

"We have done parody commercials and the opening sequence. Some years we just do the graphic design; other years we create the whole thing, from soup to nuts. Sometimes our responsibility is somewhere in between. Our client is always first Jim Signorelli, the man who has directed almost every parody commercial since the show began in 1976, and then Lorne Michaels, the show's creator and executive producer.

2 SATURDAYNIGHTLIVE

3

"Like I said, it's always a rush. They know that the show is going to premier on the third Saturday night in September (give or take a week), and that is STILL about the time they call us every year (give or take a week). But they are used to creating 90 minutes of television in less than a week, so, to them, 90 seconds should be a breeze.

2 The current logotype for the show, introduced in 2006.

3 One of the logotypes that was aired and then rejected by "SNL" creator Lorne Michaels.

4

"We spend a few days conceptualizing, present a couple of different directions, then, depending on the year, start animating, or shooting, or storyboarding the sequence. The open continues to change throughout the editing/designing process because the cast is still in flux up to the day it airs.

"We work very closely with Jim and then at some point, often in the middle of the night, we have to present to Lorne Michaels. There are always a lot of people milling around outside his office at 30 Rock, also waiting to present other things to him: scripts or costumes, or just hanging around. It may be 2am but in Lorne's office it feels like 2pm. Everyone is full of energy and seemingly has no idea that the rest of the city is sleeping.

"One year, we had to actually run the physical videotape (when things were still done on videotape) over to NBC studios from the edit room with less than 15 minutes to spare before the live show aired. It was just like that scene in *Broadcast News* where Joan Cusack hurdles her way to the video deck.

4 One of the spoof ads produced by Number 17 for "SNL": Cookie Dough, a parody of a Gatorade sports drink ad, featuring Will Ferrell.

"The best experience, though, was when we finished the open the day before the show aired and we went to the show itself, sat in the audience, and watched the opening sequence come on with everyone else. It was an amazing moment for us.

"The current opening feels very current and bold without being trendy. One of our favorite parts of the package, though, is always the bumpers (the five-second pieces that air between the show and the commercials). There are 12 different bumpers and we love how each one reinterprets the aesthetic of the open and highlights a different aspect of the city at night. Also, we get to use footage that never finds a home in the open.

"The opening sequence that was on for the 2007–8 season was actually held over from the year before, so it was a quiet September in 2007. But in 2006, they asked us to design a new logo to go with a new open (we designed the logo they were currently using in 1997). Radical Media was handling the live-action party-scene shoot and we created and edited the graphics. We presented a few logos and Lorne Michaels chose one and we cut the open and it aired.

"Then on Monday morning we heard that Lorne didn't like the new logo and wanted to go with a different one we had presented. So, we re-cut the open with a new logo and that is what aired on Week Two. Then, we got another call—this is true—for another logo, which aired the following week. And two years later, that is still the logo."

5 The Crystal Gravy spoof of Crystal Pepsi, broadcast in 1993.

6–7 Opening titles storyboards from 2001 and 2002.

Index

Acknowledgments

I would like to thank the inspirational
individuals who agreed to tell all
about themselves and their work,
and put up with months of questions,
requests, emails, and phone calls:
Jonathan Ellery and Nick Jones at
Browns; Fred Vanhorenbeke at
Coast; Mario Eskenazi; Jason Grant
at Inkahoots; Pann Lim at Kinetic;
Javin Mo at Milkxhake, and
Bonnie Siegler and Emily Oberman
at Number 17.

Thanks also to my beautiful family,
Samantha, Lucas, and Thomas, for
their support in everything I do.

The publisher would like to thank
Nicola Hodgson and Fineline Studios.